DEGAS

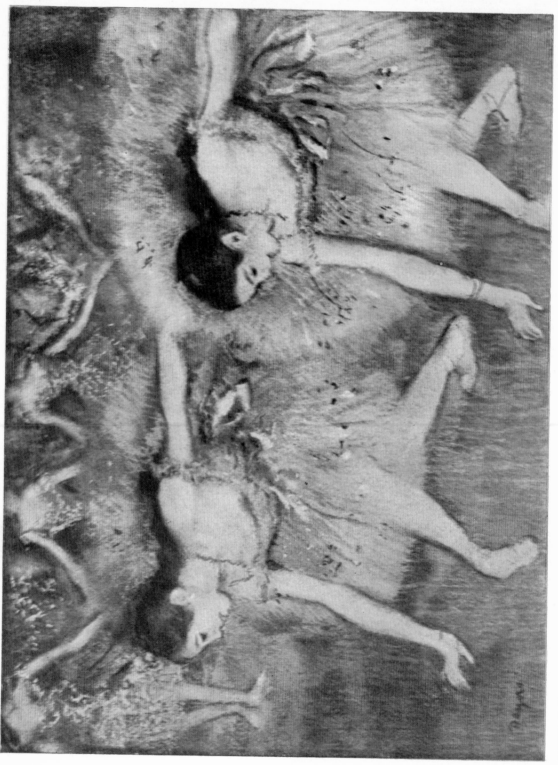

TWO DANCERS

DEGAS

An Intimate Portrait

By AMBROISE VOLLARD

Author of CÉZANNE and RENOIR

Authorized Translation from the French by

RANDOLPH T. WEAVER

Profusely Illustrated

CROWN PUBLISHERS

NEW YORK

PRINTED IN THE UNITED STATES OF AMERICA

TRANSLATOR'S PREFACE

The present volume makes no pretence of being other than the most informal of biographies, composed of notes jotted down casually and bits out of the author's experience in the course of his long and pleasant acquaintance with the artist. It is difficult, indeed, to write of Degas in any other way, for the personality of this deft portrayer of little ballet "rats" and race-courses is as elusive as one of those canvases of his, in which the grace and beauty of a fleeting movement have been captured and recorded for all time. A race-horse pawing the ground, a laundress ironing a shirt, a dancer tieing her shoe— all these arrested movements have been imbued with permanence by the magic of his brush.

The incidental note struck in his pictures seems true also of his life. Like most geniuses he was essentially independent of events, persons, and places, refusing to be limited by time and disregarding as unimportant everything which did not include and enrich his work.

Much has been written on Degas, the man and the artist. His work has been so well and so often appraised that he is now widely known and appreciated in almost every civilized country. It is obvious, however, that what further light can be thrown on his nature will serve as a welcome aid to a better comprehension of his work. Mons. Vollard has thus given us in the following pages a document of no small importance. In a few swift and vivid flashes the figure of the master stands out clear and poignant, drawn with the same verve and subtlety as are to be found in one of his own delightful pastels for which he was so justly famous. R. T. W.

5

CONTENTS

LIST OF ILLUSTRATIONS

IN COLOR

HALFTONES

DEGAS

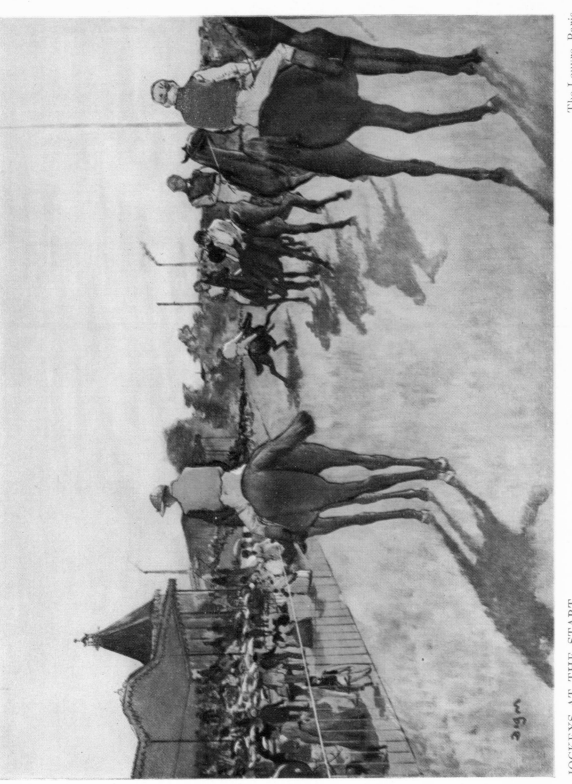

JOCKEYS AT THE START

The Louvre, Paris

INTRODUCTION

Hilaire Germain Edgar Degas had the misfortune to be identified against his will with a "school." From the day he joined forces with the Society of Painters, Sculptors and Gravers, later dubbed Impressionists, and exhibited at Nadar's photographic gallery on the rue des Capucines, he too became known among that contemptuous general, to whom he was not caviar, as an Impressionist.

What a fate! It was as if Poussin had been accused of vulgar realism, or Delacroix rated a classicist because his productive years paralleled those of David's feeble followers. For *plein-air,* the war-cry of Monet and his group, was anathema to Degas, even though he continued to exhibit with the Impressionists. At a Monet exhibition he turned up his coat-collar for fear of catching cold; too draughty, he said. With his feet firmly planted in tradition, Degas' constant search was for plastic movement, and yet, because his line was freer and looser than Ingres', and his color, even in his early work, more lucid than the run of contemporary bitumen, he was lumped willy-nilly with the rising group whose very tenets he disdained.

In fact Degas' career, in relation to these contemporaries of his, was much like Chardin's. While Boucher

and Watteau celebrated the *fêtes galantes* of the court, and made of every cow-girl a bit of Dresden china, the good Chardin, his white kerchief knotted about his head, was peering through horn-rimmed spectacles at the baker's wife in the bread shop, and setting down faithfully the placid life of the middle classes. Similarly Degas stuck to his attic studio, with occasional forays among ballet schools and cafés, while his sterner contemporaries fought mosquitoes and braved sunstroke in the fields and woods in search of the illusive aspects of the out-of-doors.

It is easily understood, however, why Degas was accepted long before his fellows. He dealt with accepted things in an illustrative manner, and though his visual angle shocked the amateurs and his searching impersonal realism worried the moralists, it was at least a comprehensible world that he saw and recorded.

Degas was never greatly pre-occupied with color as such. He was out of sympathy with the blond scheme of the luminists and Cézanne's struggle to force color to express formal values left him cold. He tells us himself that he should probably have stuck to black and white if the world had not clamored for more and yet more of those vivid pastels, wherein he used patches of red, green and yellow to such superb decorative effect.

Degas' career offers strong proof of the fact that a painter must live long to live forever. There are few exceptions. Masaccio, Raphael, Watteau—these are the rare Shelleys and Keats of painting. But most great figures in the history of art developed the manner we know them by late in life. Daumier's feeble early drawings hardly pre-

saged the powerful paintings of his middle years, and Cézanne's frustrated attempts would not have made him a *chef d'école* if he had died when Zola wished he had. In Degas' case, it is doubtful if his classical efforts, unconventional enough to win him honorable rejection at the hands of the Prix de Rome jury, or his racing scenes or his subject pictures would have gained him the same reputation as his long line of dancers, laundresses and lonely prostitutes.

Given talent, an original point of view, vitality, it would indeed seem that time is the fourth essential to the attainment of immortality. Van Gogh stands out as the single exception among recent painters. He crowded the major portion of his work into six frantic years, and died a madman. With him, painting was pure feeling, but who can tell what extraordinary results he might not have attained, given twenty years of calm wherein to organize and regulate his sensations? As it is, he is a sport in the development of modern painting, standing outside the movement, a religious lyricist, one whose work can never deeply influence the trend of the plastic arts because it is too personal.

Degas, on the other hand, developed slowly, surely. For all he may say that he would have been bored to death if he had "found his manner," his style is as recognizable as Blake's, and brooks no imitation. It is clarity itself. To the painter, as to all creative artists, it doubtless seemed fumbling and incomplete. But to us it seems only to gain in sureness and mastery to the very end.

Vollard has given us in these pages a strangely vivid sketch of Degas as man and artist. It is a sketch indeed,

done with the greatest economy of means. But who shall say that it is not a better portrait than a detailed biography, even as some of the painter's own sketches are more alive than his finished work? It has always been Vollard's method in his books to leave as much to the subject's own lips as possible. For that reason his almost stenographic reports of Cézanne and Renoir have become source-books, which later writers have freely drawn upon. For Degas, in this volume, he has done a similar service.

Such men as these have little to offer the biographer who seeks the bizarre or the adventurous. They travelled little, they worked much. Little or nothing happened to them outside their art. Indeed, Degas, immured in his Paris studio, was so little of this world that he became almost a legend. He was pictured as a sort of monster whose misanthropic furies against those who tried to force his friendship were unbounded. In the latter years of his life, there was a story current that an old friend, having obtained permission from Degas to visit his studio, was met by a bearded demon at the door and thrown bodily down the stairs. It was also told how, when increasing blindness obliged him to cease work entirely, he would hire a taxi-cab and drive slowly through the streets of Paris, bowing to right and left in acceptance of the applause of the mob. But if this strange procedure elicited derision, so the tale went, he would roar in a rage: "Don't you know that I am Degas?"

What a contrast to Vollard's picture of the poor old man, in his shabby cape, his long beard unkempt, trudging

INTRODUCTION

off to the excavation where his former studio had been, and peering pitifully through the fence with unseeing eyes!

But such is folk-lore and such it will always be until someone like Vollard paints a new picture of the real man.

<div align="right">HAROLD L. VAN DOREN</div>

DEGAS
1834–1917

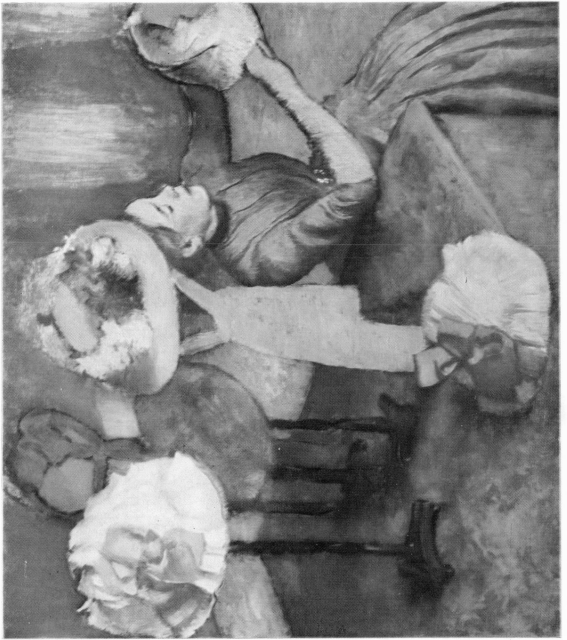

THE MILLINERY SHOP

DEGAS

Early Encounters with Degas

DEGAS: I don't want you any more!

THE MODEL: But you always said I posed so well, Monsieur Degas.

D.: Yes, but you are a Protestant, and the Protestants and Jews are hand in glove in the Dreyfus affair.

Degas was not always consistent, however. I remember when I was going to see him one day I ran into Monsieur L., a notorious Israelite, in the doorway. I asked him if Degas was in; he nodded and said:

"Degas and I have not been seeing much of each other since the 'Case,' but yesterday I had a note from him asking me to drop around to his studio. He had heard of my wife's death and wanted to tell me that he would give me a portrait he had done of her some time ago."

I found Degas putting a portrait of a woman, which seemed unusually finished, back into a folio.

"I'll have to touch it up a little," he remarked as I came in.

"I am sure Monsieur L. ought to be very grateful to you," I said.

He sighed. "Yes— How pleasant it would be to give

21

people things if you only didn't have to listen to their thanks."

Just then a delivery boy entered, carrying a basket full of toys.

"My friend J.'s children are coming over day after to-morrow to wish me a Happy New Year," Degas explained. "I've got to be prepared, you know. I've been rummaging around in Place Blanche, and this is my first haul. Isn't that a magnificent soldier? And what do you think of the doll? The elephant is for me. They assured me it was real skin. It was the trunk that tickled me most; see how it lifts up when I pull the string?"

I had come to invite Degas to dinner that evening.

"Certainly, Vollard," he said. "But listen: will you have a special dish without butter prepared for me? Mind you, no flowers on the table, and you must have dinner at half past seven sharp. I know you won't have your cat around and please don't allow anybody to bring a dog. And if there are to be any women I hope they won't come reek-ing of perfume. How horrible all those odors are when there are so many things that really smell good, like toast—or even manure! Ah—" he hesitated, "and very few lights. My eyes, you know, my poor eyes!"

Degas used to pretend to be more blind than he was in order not to recognize people he wanted to avoid. But one day he ran into an acquaintance of thirty years' standing and asked him his name, adding, "It's my poor eyes, you know." Then he forgot he could not see and pulled out his watch. . . .

Degas' studio was always in a state of confusion. He

would not permit the least thing to be touched. In consequence the room was a clutter of all sorts of objects, from painting materials to piles of magazines and pamphlets.

One day when I came to see him I happened to be carrying a package under my arm. A tiny piece of paper, no larger than a bit of confetti, worked loose from the wrapping and fell on the floor. Degas pounced on it, dug it out of the crack where it had lodged, and threw it into the stove. "I don't like disorder," he said.

But if Degas did not wish to "see" he was very anxious to hear, in spite of the fact that he was somewhat hard of hearing. He always insisted that people talked indistinctly or badly, and a whole evening spent carefully articulating each word was as good as wasted if one happened to say *au revoir* a little more hastily than usual.

Degas was much beset by bores, and if he found he could not reasonably escape them by his favorite excuse of not seeing—as when he was invited to hear Madame X.'s beautiful singing—he would say, "It makes me dizzy."

One day when Renoir was telling me how he was victimized by all sorts of people, I said:

"Why don't you do what Degas does: tell them it makes you dizzy?"

"Yes," replied Renoir, "but do you think they will let me off as easily as that?" He glanced down at his feet, which had long since refused to serve him, and muttered, "Degas has his legs, at least."

There is no doubt but that Degas was a good deal of an eccentric, and his whims and odd retorts naturally only increased this reputation. Yet, even so, people were too

easily inclined to judge him unfairly because he resented being imposed on and dragged about to exhibitions of paintings or nine o'clock dinners and made to sit at a table which looked like a florist's window, simply because it was the thing to do.

A FEW PREJUDICES AND OPINIONS

"I remember a dinner I went to at Monsieur Lambert's, the silk dealer," Degas said to me one day. "Lambert turned to Guillemet, who was a close friend of his, and said, 'Here are thirty louis. You go around the studios, don't you? See if you can't pick up a bargain or two for me.' Guillemet went directly to see Corot, and taking out the money said: 'Have you anything you could let me have for my friend Lambert?'

"'Your friend is generous,' replied Corot. 'Thirty louis! I shall have to give him something very . . .'"

"Nowadays," I remarked, "if you went to the least expensive of these young masters——"

Degas interrupted: "Guillemet came away with two Corots. Lambert thought them very beautiful and asked Guillemet if he couldn't get Corot to come to dinner to approve the gold frames he had bought for them. Corot accepted, but he added, 'You know, my hour for dinner is six o'clock.' I had been invited too, and when I said half-past seven—" Degas gave a slight shrug and then continued:

"We were told that there would be a surprise at dessert; so after we had eaten the raspberry ice, the door at the end of the room opened, and in came two little 'rats' from the

25

Opera." (Lambert was a subscriber.) "They executed a
few steps, and then tripping up to Corot, popped a crown
of roses on his head. Corot drew them onto his knees and
kissed them both. I did a sketch of them while they were
dancing. At eight o'clock Corot got up to go home to bed
according to his custom, and I went around to Camart's,
the printer, and put my sketch on copper.

"It is very nice to have parties after dinner. . . . But
that is impossible nowadays because dinner is always
served so late."

I remarked to Degas that people were in the habit of
dining later than ever because every woman feared that
she might pass unnoticed unless she were the last to arrive.
And with that as a basis, I made a few other general ob-
servations regarding women and fashions. Degas caught
hold of my arm and said:

"Vollard, please do not say anything against fashions.
Have you ever asked yourself what would happen if there
were no fashions? How would women spent their time?
What would they have to talk about? Life would become
unbearable for us men. Why, if women were to break away
from the rules of fashion—fortunately there is no danger
—the government would have to step in and take a hand."

No one believed more than Degas in the need for dis-
cipline in every phase of life, a need which seems somehow
ridiculous these days. But Degas boasted that he belonged
to another era, when there was order in the world, and
everyone kept to his own station in life. For this reason he
felt offended if, for instance, anyone tried to shake hands

with him and say "Good morning, Master." People were often astonished when he showed his claws.

Only once did Degas ever restrain himself and then because he was at a loss for words. He had met the Douanier Rousseau while out walking one day, and, after a minute's conversation, Rousseau naïvely inquired:

"Well, Monsieur Degas, are you selling pretty well these days?"

The Mirbeau Incident

One afternoon Degas was at my shop when Mirbeau came in. He had his famous Dingo with him on a leash.[1] I expected a characteristic passage of wit between Mirbeau and Degas, but Mirbeau was embarrassed by a kind of dominating influence which Degas had. But Degas was reserved. They hardly exchanged two words. Suddenly Dingo jerked his leash free when his master was not looking, and ran upstairs to the next floor. Mirbeau seemed very uneasy about it. He said: "How will I ever catch him again? He will bite me." And, seeing my astonishment, he explained:

"Whenever a dingo gets loose from his master in a strange place, he reverts to his savage state immediately. I once read a story about it which told how a man went off alone on an excursion into the pampas. He was on horseback, but he took a dingo along with him on a leash. The first day out the man fell from his horse, and the minute he touched the ground the dog went straight for his throat. . . . They are extremely powerful too. Do you know this dog of mine knocked a heavy wooden chicken-house to pieces the other day as if it were so much straw. . . ."

I suddenly remembered that the servant was upstairs, and I was just picturing her, struggling for her life in the jaws of the dingo, when she appeared, leading the dog in.

[1] Author's Note: See "Dingo," by Mirbeau, published by Fasquelle; Paris.

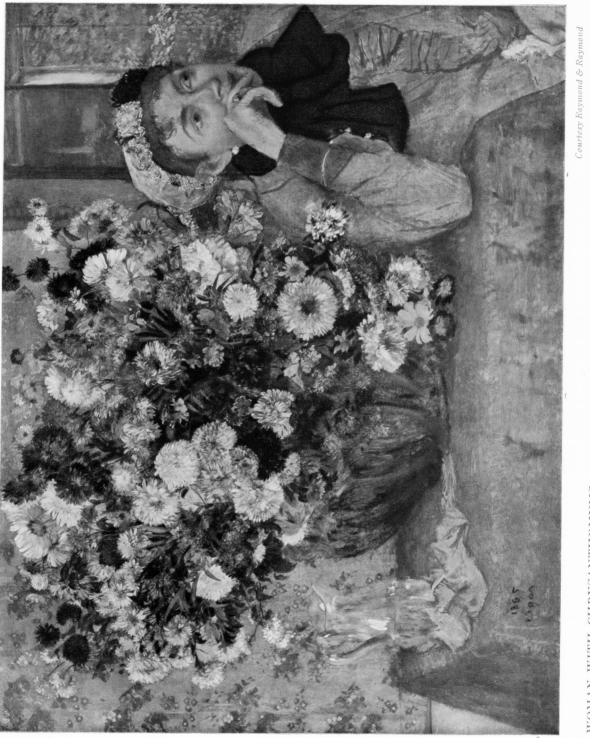

WOMAN WITH CHRYSANTHEMUMS

"What's the matter with this dog?" she asked. "He was half-scared to death all by himself up there. . . ."

"Isn't my Dingo a handsome dog?" Mirbeau asked Degas a few minutes later.

Degas uttered a little laugh which he intended to sound affable. Then there was a complete silence.

I began to tell Mirbeau of a mean trick a lawyer had played on a client one time. Mirbeau became alarmed and got up to go without waiting to hear more.

"Do you mean to tell me that lawyers do things like that?" he asked. "I have money invested in a law firm— . . . Excuse me; I must be off right away."

"But you said you were showing up the legal profession in your book," I said.

"Does a writer have to believe in everything he writes—?" Mirbeau began, with a provoked air.

Degas had gone by this time, and as Mirbeau was leaving, he remarked, "Degas seemed very glad to see me, didn't he?"

When next I saw Degas I mentioned Mirbeau to him.

"Mirbeau?" he said. "I used to know him a long time ago; but I shouldn't recognize him now. . . . He writes, doesn't he?"

It must not be thought that Degas was insensitive to all literature. When he breakfasted his old servant, Zoé used to read the "Libre Parole"—of Drumont's day—aloud to him. Degas had only one fault to find with Zoé and that was that she read without expression. Besides the "Libre Parole" Degas took the "Figaro" every Monday on account of the drawings by Forain, which he was collecting.

DEGAS

Degas' life was as ordered and arranged as a sheet of music; he was in his studio from morning till night. When his work went well he usually hummed some old tune. He could be heard on the stair landing singing a snatch of song such as:

"Sans chien et sans houlette
 J'aimerais garder cent moutons dans un pré
 Qu'une fillette
 Dont le coeur a parlé." [1]

Degas often teased and joked with his models.

"You are a rare specimen," he would say gravely; "you have buttocks shaped like a ripe pear—like the Gioconda," and the girl would go about showing off her buttocks with the greatest possible pride.

But though Degas allowed himself occasional liberties in familiar talk around his studio, he never treated his models with the least indelicacy. Nor did he tolerate any presumption on their part.

One day one of his favorite models was looking at a drawing of herself and suddenly exclaimed:

"Is that *my* nose, Monsieur Degas? My nose was never like that." She was thereupon put out of the room without further ado, and her clothes thrown out after her. And she was left to dress sadly and thoughtfully on the landing at the head of the stairs.

[1] "Without dog or crook
 Rather had I keep an hundred sheep within a fenceless field
 Than a maid
 Whose heart love hath unsealed."

30

Zoé

From time to time Degas would invite a friend to dinner.

"You shall have some of Zoé's orange marmalade," he would promise, as if to make a special occasion of the evening.

And Zoé, who was not in the least unaware of how much her preserves were appreciated, would take advantage of the situation. The first time I went to see Degas he was at lunch, usually the best hour to find him in.

"Zoé," the painter called out sharply; "I am having company for dinner this evening."

"No, monsieur; you will have to take your friend to a restaurant. I don't want you around this evening."

Degas' expression had grown very severe. What with his reputation for being a hot-tempered man, I fully expected he would get up and strike Zoé. But she went on serenely:

"I am making jam today, and I don't want to be disturbed."

"Very well," was all Degas said, and after Zoé had gone back to the kitchen I remarked:

"Did you know, Monsieur Degas, that most people think you very hot-tempered?"

31

"I want them to think me so," he answered.

"But you really are good-hearted."

"I don't wish to be good-hearted," he said.

Meanwhile Zoé had brought in the salad. Degas always dressed it himself, for the exact amount of oil required was almost a rite with him. He reached for the oil cruet and found it empty.

"Haven't you any oil?" inquired Degas.

"I'll go get some, monsieur. There's a shop next door."

Zoé returned a quarter of an hour later.

"Well, where's the oil?" asked Degas impatiently.

Zoé was flustered. "I'll go right back, monsieur," she apologized. "I made a mistake and got vinegar."

Degas managed to remain calm, and when the servant had gone out again, he sighed, "Poor Zoé!"

"Whom did you have before Zoé?" I inquired.

"Sabine was with me before Zoé. She made good orange marmalade too."

Degas told Sabine one evening that some friends were coming in and that she had better make something for them to drink. Sabine therefore prepared another drink in addition to the customary camomile for her master. "What is this concoction you are giving us, Sabine?" one of the guests inquired.

"Do you like it?" she asked eagerly. "The master told me I must get something good, so I bought some licorice at the corner and warmed it up with a little sugar."

Degas' soirées were of course somewhat different from the one the Baroness of Cl. T. gave in his honor. When the

evening was over, a valet called for the attendants of the Prince of W., the English ambassador, and other gentry.

"But," exclaimed a lady who did not know just how important a personage Degas might be, "what about Monsieur Degas' attendants?"

"Monsieur Degas' attendants are Zoé," replied the painter, "and she has been asleep in bed since eight o'clock."

DEGAS' GOOD NATURE

It is almost a commonplace that Degas had a peculiar hatred of women. Yet on the other hand, no one loved women as he did; but a kind of shame or modesty in which there was something like fear, kept him away from them. It is this prudish trait in his nature which explains in part the sort of cruelty which often led him to depict women at the most intimate moments of their toilet.

Another commonplace was the abusive flavor of his speech. But he had a very sensitive side to his nature which people refused to perceive.

A mother was reproving her little girl one day for making mistakes in spelling.

"Why do mistakes in spelling matter?" the child protested.

"Why do they matter? Because they do, and it is very naughty in a little girl to make them, isn't it Monsieur Degas?"

"Very naughty," agreed Degas.

Then when the mother had left them, Degas said to the child: "Which would you like best: to know how to spell or have a box of candy?"

"Candy!" cried the little girl without hesitation.

"Well, so would I," replied Degas.

34

One time when Degas was dining at Forain's house, he told a fairy tale to Jean-Loup, the small son of the painter. The child listened in wonder, and then asked: "Were you there, Monsieur Degas?"

"No," replied Degas, "but my nurse, who told me the story, said she was there."

And this was Degas, the real Degas, altogether different from the terrible man that legend has depicted: a sort of ogre who detested children as much as he did dogs, cats, and flowers. It is said that once when a child happened to tap his plate with his knife, Degas cried out roughly, "What's that racket!" which so frightened the youngster that he immediately turned pale and vomited all over the table.

Degas was really very good-natured, and showed it with all kinds of people. One evening, as he was passing through the Parc Monceau, he tripped over some wires which had been strung across the lawn. A passer-by was sympathetically indignant, and exclaimed: "That's like them to put those wires there just to make people break their necks! . . ."

"No," rejoined Degas drily, "they're put there to keep people from setting up too many bad statues in the grounds."

Degas rarely ever indulged in anything more than mildly biting repartee except when art or "the established order" was attacked. Bonnat, for instance, was showing him a picture by one of his pupils, representing a warrior drawing his bow.

"Just see how well he aims!" said Bonnat.

"Aiming at a prize, isn't he?" replied Degas.

Another day an art critic, Monsieur S., and I were with Degas on the way to the Salon. "All blue doesn't come in ink bottles, my friend," said Degas. "Some of it comes in tubes."

We had arrived at the Salon. Monsieur S. took Degas up to a portrait of a *Woman with a Corsage Bouquet*. Degas' comment was:

"Fantin-Latour has a great deal of talent, but I'll wager that he has never seen a woman with a corsage bouquet in his life."

Degas never lost an opportunity to proclaim Carrière one of the great painters. Yet that day, as he inspected the different pictures and stopped in front of the Carrières he was irritated because the art critic kept pointing them out to him, and his only comment was, "I can't see very well today."

36

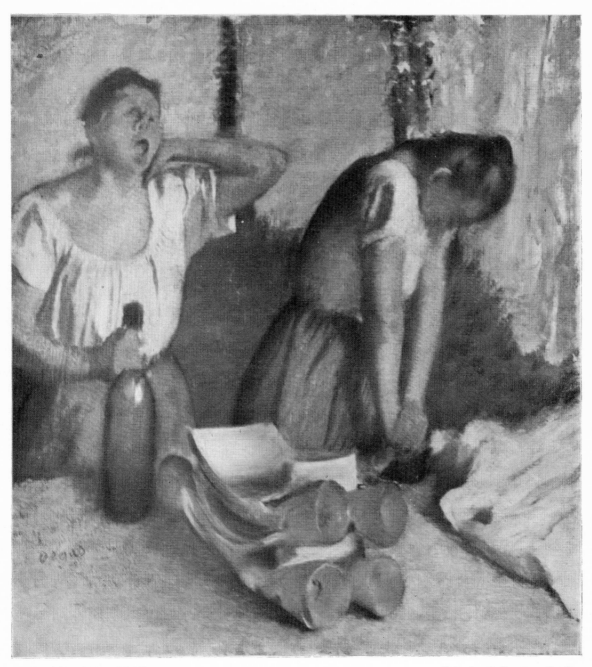

THE LAUNDRESSES

Degas stopped to look at each canvas, and presently gave a little exclamation of disgust. "To think," he remarked, "that not one of these fellows has ever gone so far as to ask himself what art is all about!"

"Well, what *is* it all about?" countered the critic.

"I have spent my whole life trying to find out. If I knew I should have done something about it long ago."

Suddenly we heard someone call "Monsieur Degas!" It was Vibert, the well-known painter of *The Cardinals*.

"You must come to see our exhibition of water-colors," he said. Then he gave a sidelong glance at the old mackintosh Degas was wearing, and added:

"You may find our frames and rugs a little too fancy for you, but art is always a luxury, isn't it?"

"Yours, perhaps," retorted Degas; "but mine is an absolute necessity."

* * * * *

I remember a walk I took with Degas along the Grand Boulevards. Everywhere we went the shop-windows were loaded with nothing but gilded gim-cracks.

DEGAS: You never used to see rubbish like that before the Dreyfus Case came up. The time will come yet when we will be ready to weep for joy at a mere display of umbrellas. Take this umbrella shop here, for example; it has a good old-fashioned French look about it. I am going in to buy a cane.

We entered, and the shopkeeper showed Degas two canes of exactly the same wood and mounting except that the handle of one of them had a leather band and loop. It was the cheaper of the two.

Degas (to the man): Why is the plain one more expensive? Is it in better taste than the other?

The Shopkeeper: Good taste is always costly, sir.

Degas went out wrapped in thought.

Degas: Where will it ever end? Everything is topsy-turvy nowadays. Just the other day I actually saw a little girl playing with a paint-box. The idea of giving such things to a child!

* * * * *

One day I was going along with Degas in Rue de la Chaussée d'Antin, when we came to a large store.

"I am going to leave you here," I told him. "I've got to go in and buy some toys. . . ."

Degas, then, always ready to mistrust the Jews, exclaimed:

"What! Do you patronize Jews? There is another place just a step further on, where there are Catholics who will sell you honest goods and at a better price."

And so, under Degas' guidance, I proceeded to the Catholic establishment, where I asked to see a steam-engine.

"That is a specialty," the clerk informed me, "and we will have to send to the factory for it. It will take two weeks."

I was annoyed, and the man continued:

"I know it is only nine days till New Year's, but we are not responsible for delayed railroad deliveries."

I decided not to order it, but several days later I chanced to be passing the Jewish store, and went in to see

what they could do for me. Here again I was told that they would have to send to the factory.

"We cannot usually get a delivery in less than two weeks," they said, "but that will bring it after the first of the year. So we will try to get it here sooner by express."

Later on I ran into Degas at a party. As soon as he saw me he exclaimed: "If it hadn't been for me, Vollard would have let himself be cheated by Jews the other day! . . ."

We were talking about the revolution of 1847. Somebody remarked to Degas that he must have been quite young at that time. Said Degas:

"I remember a story my father used to tell. As he was coming home one day, he ran across a group of men who were firing on the troops from an ambush. During the excitement a daring onlooker went up to one of the snipers who seemed to be a poor marksman. He took the man's gun and brought down a soldier, then handed it back to its owner who motioned as if to say, 'No, go on. You're a better shot than I am.' But the stranger said, 'No, I'm not interested in politics.' "

Degas always liked stories of the past. Someone was telling about the young man who was out boating with two ladies when one of them put him in an embarrassing predicament by asking: "If we were threatened with death and you were able to save only one of us, which would it be?"

Degas laughed. "I know one as good as that," he said. "Madame de Staël was in a little boat on Lake Geneva one day with Madame de Récamier and Benjamin Constant. All at once one of the rowers remarked that there was a

40

cloud on the horizon which looked like rough weather. 'Tell me, Benjamin,' said Madame de Staël; 'if we were ship-wrecked, which of us two would you save.' 'You,' Constant replied, 'because you know how to swim.' "

The Sensitive Artist

One day when I was with Degas we ran across Monsieur Michel L., a painter whom he had known for a long time. Degas passed him by without so much as a glance. "We once exchanged pictures," he explained to me afterwards, "and would you believe it, I found the one I had given him for sale in a shop. I took his own back to him the next day."

"What did he say to that? I shouldn't think that a man who can afford Watteaux would ever find himself in need of ready money."

"Oh, I didn't even ask to see him. I just left his canvas on the door-step along with the morning's milk."

Degas had once made a present of a pastel to another of his friends, the painter Z., who later sold it. Degas was offended, and afterwards when they happened to meet, he walked by without a word. But Z. ran after him and burst out with: "Really, Degas, I've had such terrible expenses —my daughter was married, you know. . . ."

"Monsieur," interrupted Degas, "I do not understand why you should tell me about your family. I really have not the pleasure of knowing you."

* * * * *

THE SENSITIVE ARTIST

Degas has often been reproached for his unrelenting attitude towards people.

"If I did not treat people as I do," he would say in his own defence, "I would never have a minute to myself for work. But I am really timid by nature; I have to force myself continually. . . ."

It may seem surprising to Degas' admirers that he thought it necessary to be violent in order to overcome his timidity. But one gets an inkling of the true character of the man in a letter to a friend, to whom he reveals the state of his soul:

"I am going to ask you to forgive me for something which keeps coming up in our conversation, and still oftener, I am sure, in your own thoughts, and that is, that throughout the course of our professional relations, I have been, or seemed to have been, 'hard' with you. I have been singularly hard with myself. I have had to be. You must realize that this is so, since you have, at times, reproached me for it, and were astonished because I had so little confidence in myself. I have been, or seemed, hard with everyone because I was carried away by a sort of brutality born of my distrust in myself and my ill-humor. I have felt so badly equipped, so soft, in spite of the fact that my attitude towards art seemed to me so just. I was disgusted with everyone, and especially myself. I ask your pardon, then, if, with this damned art as an excuse, I have wounded your noble and intelligent spirit; perhaps even your heart. . . ."

THE CRIME AND THE PUNISHMENT

Degas had just entered the house one day when Zoé informed him that Monsieur Lotrin had called while he was out.

"Lotrin is too ugly a man for me not to distrust him," remarked Degas. "If he comes back, Zoé, don't let him in until I've seen him outside first. I want to ask him a question."

Lotrin did return, and Zoé made him wait on the doorstep. Degas half-opened the door, put his nose through the crack and demanded, "Are you for Dreyfus?" Lotrin confessed to Nationalist leanings, and was allowed to come in. Degas was then very sociable, inquired after his friend's health, and asked about his wife and daughter.

Such forbearance was all the more remarkable in view of the way the public habitually imposes on artists. This was especially true in Degas' day. There are always plenty of the kind of people who, once inside a painter's studio, proceed to make themselves quite at home, nosing into covers and cases, and handling any canvas that happens to catch their eye. Zoé of course never allowed anyone to penetrate as far as the rooms downstairs where her master's pictures were kept. But when visitors found the living quar-

ters forbidden them, they were undaunted and calmly went up to the studio instead.

One morning I had gone to get a picture from Degas. The light was exceptionally favorable for painting that day, and the master was already hard at work. Just then the bell rang; someone had come to bring New Year's greetings, and, to ask, incidentally, if he could bring up a friend who was waiting in a carriage outside.

"Not at this time of day," replied Degas. "Come at half-past one, before I start to work again, or else after dark."

When he had departed, I said, "Monsieur Degas, may I bring someone to see you at those hours too?"

"If you wish, Vollard."

There was a collector who had been wanting for a long time to see Degas' studio. Armed with the painter's permission, I told my friend I would take him to see Degas. He was overjoyed, and said:

"If you don't mind, I will bring a friend along with me."

I did not see any way of refusing. But, just then, someone else arrived, who was immediately told of the proposed visit.

"I should be very glad to go with you," he said, and, noting my embarrassment, he added, "Oh, I know Degas very well."

That made four in our party to begin with; but I was completely dumfounded when we were ready to go, for one of them had brought his wife, and the other, two more

friends. We must have looked like a regiment when we appeared at the painter's door.

Degas had just risen from the table. I went in first and left the rest at the foot of the stairs. When I explained the situation to him, he started to expostulate, then changed his mind. For Degas' innate courtesy forbade him to keep anyone waiting long at his door, and he only said to me as he went to receive his visitors: "I'll come by to see you at your shop. I have something to say to you——"

Degas' manner towards his "guests" was rather cold at first, but I managed to divert his bad humor by remarking that we had seen an Impressionist exhibition at Durand-Ruel's as we came along.

"Don't talk to me about the Impressionist," he exclaimed. "They ought to be—" He seized a cane from one of the party, put it up against his cheek like a gun, and was raising it towards the ceiling to aim, when the portrait of Monsieur Leblanc came within range. He lowered the cane and said:

"Why, I was just about to shoot Ingres!"

ONE OF THE VISITORS: Monsieur Degas, were there any of Monet's pictures at the Durand-Ruel exhibition?

DEGAS: Why, I met Monet himself there, and I said to him, "Let me get out of here. Those reflections in the water hurt my eyes!" His pictures always were too draughty for me! If it had been any worse I should have had to turn up my coat collar.

VOLLARD: I understand that you are not on very good terms with Monet.

46

D.: No—, not since the "Affair." I made up with him for the sake of convenience.

ANOTHER VISITOR: How did you manage, Monsieur Degas, when you painted that *plein air* called *Le Plage,* the one Monsieur Rouart has?

D.: It was quite simple. I spread my flannel vest on the floor of the studio, and had the model sit on it. You see, the air you breathe in a picture is not necessarily the same as the air out of doors.

I was not overly reassured when we had left Degas; the visit he had threatened to make me boded no good. I tried to think of something which might placate him a little at least. I displayed *The Little Girl on the Blue Sofa* by Mary Cassatt (whose talent Degas admired so much) in a prominent place in my shop. At the first exhibition the Impressionists gave, Degas had asked Mlle. Cassatt to give him the canvas she was exhibiting there in exchange for the finest of his nudes. He had a particular affection for *The Little Girl on the Blue Sofa,* for it had been painted under his guidance, and he had been generous with suggestions about the composition.

Degas was the most helpful and valuable friend imaginable when it came to advice and criticism in painting. When Gervex was at work on his *Lesson in Anatomy* Degas said to him: "Did you ever see a student taking notes while the professor is lecturing? . . . He ought to be rolling a cigarette."

And it was this bit of advice which made the picture.

However, when Gervex was doing his *Rolla,* Degas happened to see the picture, and again made recommendations.

"You must make it plain that the woman is not a model. Where is the dress she has taken off? Put a pair of corsets on the floor near by."

The canvas was refused by the Salon on grounds of indecency.

"You see," said Degas afterwards, "nude models are all right at the Salon, but a *woman undressing*—never!"

* * * * *

Degas made his threatened visit sooner than I expected. On arriving at my shop, he stopped at once to look at the Cassatt.

"She has infinite talent," he remarked musingly. "I remember the time we started a little magazine called *Le Jour et La Nuit* together. I was very much interested in processes then, and had made countless experiments. . . . You can get extraordinary results with copper; but the trouble is that there are never enough buyers to encourage you to go on with it."

"The smallest plate you ever made would sell now, Monsieur Degas. . . ."

"Nobody would buy etchings when I was interested in doing them," he answered. His eye fell on one of Gauguin's pictures, and he went on:

"Poor Gauguin, 'way off there on his island! I'll wager he spends most of his time thinking of Rue Lafitte. I advised him to go to New Orleans, but he decided it was too civilized. He had to have people around him with flowers on their heads and rings in their noses before he could feel at home. Now if I should leave my house for more than two days . . ."

48

"Do you know New Orleans?" I asked.

"I went there once. I had relatives there." He began to laugh. "I can't help thinking of a negro named Fontenelle who belonged on the family plantation. How do you suppose a rascal like that ever came by such a fine name? But he wasn't satisfied with it, at that. The minute the cannon was fired to announce the end of slavery, 'Monsieur' Fontenelle went straight to town and had some visiting-cards printed with the new name he had assumed:

<div align="center">

CHARLES BRUTUS
Coloured Free-man

</div>

"And then, of course, the new free-man hurried back to his master's for supper so as to be in time for the soup."

Degas prepared to go, but at the door his hand fell on the knob; he turned and said:

"That's odd; I had something I wanted to say to you—"

He paused, and I waited fearfully; but after a moment he went on out without remembering the real purpose of his visit.

There was one person who always had her way with Degas without the slightest difficulty. It was Mademoiselle Braquaval, the daughter of one of his friends. He called her "the terrible Loulou."

Monsieur Braquaval and his family usually spent the summer season at Saint Valéry-sur-Somme. I once went to call on them with Degas.

Degas used to take great pleasure dropping in unexpectedly on the Braquavals at Saint Valéry. He would arrive at any hour of the day, according to his fancy, and would generally depart the next morning.

One day he arrived in very cold rainy weather, and as he entered the living-room, his friends cried:

"Come to the fire, Degas! We will have your room heated for you in a few minutes."

Meanwhile the rain had redoubled in violence, and Degas shook his head.

"No," he said, "it would not be prudent to stay; the weather is too bad. My doctor has warned me to be very careful not to catch a summer cold in the country."

Another time when Degas was nearing eighty, he went out to Saint Valéry during the winter. He was chilly

although he had a shawl about his shoulders and was wrapped to the ears in his muffler. Nevertheless he insisted on going out to the bridge over the river where, to the terror of his friends, he leaned upon the railing, which was loose and swayed dangerously. In answer to their protests he said:

"Oh, I know how to swim."

Degas liked Saint Valéry because he was less likely to be called "master" there than at Paris. But on the other hand, he felt that people in the country did not know as much about him as they might. . . .

Passing a hat-store one afternoon, he saw a cap in the window which took his fancy, and he decided that he must have it at once. He went in and inquired the price. Just at that time a troupe of actors had come to town and were to give a performance of "Cyrano de Bergerac" that night. The merchant, thinking, then, that he had to do with one of the artists, expanded amiably:

"I can easily see, monsieur," said he, "that you are the one who plays Cyrano."

A country journalist made a more serious *faux-pas,* for Degas had gone to see the famous Ingres at Montauban and had taken the sculptor Bartholomé along.[1] What was his consternation when the local newspaper published the following item: "We have within our gates the greatest sculptor of Paris; he is accompanied by one of his friends, Monsieur Degas, an artist from Montmartre."

* * * * *

[1] *Trans. Note:* The sculptor who designed the Statue of Liberty.

DEGAS

I had the pleasure of dining with Degas at the Braqua-
vals' in their home on the Quai de la Tournelle. Mlle. Louise
Braquaval was fond of animals, all kinds of animals in fact,
and Degas could not abide them. Dogs especially almost
drove him mad. So the animals always had to be locked up
before Degas arrived. Whenever it was forgotten, there was
sure to be trouble: a sudden uproar would rise in the hall,
in which could be distinguished the sounds of blows fol-
lowed by terrific yelps and howls. Everybody cried in
unison, "There's Degas!" and went in a body to re-estab-
lish peace. However, Loulou was so unhappy about her pets
that in the middle of a meal she would surreptitiously make
a sign to the servant to let them out. She would then pre-
tend to scold them, but they knew they would not have to
take it seriously; and in consequence Degas was obliged to
admire the Persian cat and endure the playful attentions
of the dog.

Another thing which displeased Degas as much as dogs
and cats, was having flowers on the table during a meal.

One evening he went to dine with the Forains. A little
cousin of the hostess, wishing to brighten up the table, had
set a large bouquet of roses in the center.

Degas wandered into the dining-room before dinner and
saw the offending bouquet. He seized it, and, holding it out
at arm's length, carried it through the house, which he
knew well, and dropped it at the foot of the garden wall.

The child, returning from an errand upstairs, missed
the bouquet immediately. She searched for it high and low,
and, finding it at last, bore it back triumphantly to its origi-
nal place.

When dinner was ready, Degas entered the dining-room with his hostess, but no sooner had he caught sight of the flowers again than he fled. He was captured and persuaded to return; but it was only his long-standing friendship for the Forains which made the "old serpent," as he allowed Madame Forain to call him, consent to stay.

<p align="center">*　　*　　*　　*　　*</p>

When Degas had passed his seventieth year, the doctor told him that he remained too much in his studio, and needed fresh air and exercise.

"A walk will be good for you," the doctor said. "Besides it will divert you."

"But it bores me to be diverted," his patient complained.

Nevertheless he had received his orders. Degas decided to go out for an airing for two or three hours each day. But his idea of taking the air was to climb into the nearest omnibus and, as soon as he had reached the end of the line, change to another, and even a third or fourth.

With Degas' dislike for flowers, it can be imagined just how agreeable his omnibus rides were to him, especially on Sundays during the summer when the Paris crowds would come in from the country laden with flowers and leaves. He called these trips amongst bunches of lilacs and roses, his "hygienic outings."

He once told me how much he enjoyed riding in an open carriage in the country and how much good the air did him.

I could not refrain from asking him why he did not

have a carriage of his own. He looked at me in amazement, in which there was an unmistakable trace of annoyance.

"What! *I* buy a carriage!" he exclaimed. "Would you have an artist ride in a coach and four?"

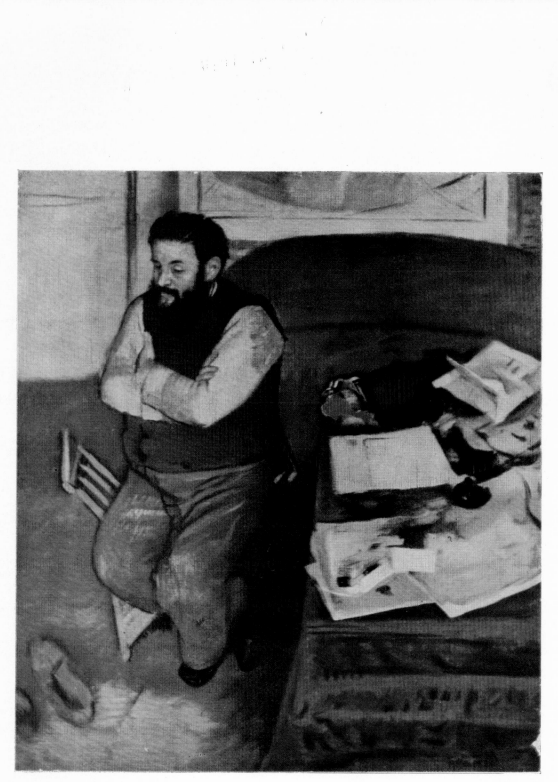

DIEGO MARTELLI

Knowing the difficulty Degas had in making up his mind to leave his studio, I was not a little surprised when he informed me that he was going to spend a fortnight with his friend Monsieur Henri Rouart at La Queue-en-Brie.

"I ought to be able to get a few landscapes out of it," he said. "Will you come to see me there?"

I was only too glad to accept his invitation. When I had arrived at La Queue, Monsieur Rouart's gardener directed me to a pavilion, where, on the door-step, I saw an old man with thick glasses, dressed in denim trousers and a straw hat. No one would ever have suspected that this mild figure was the terrible Degas.

"I've been outside long enough," he said, as I approached. "There's still a few minutes before lunch; I'm going to work a little more."

I made as if to go, but he stopped me. "Oh, you can come with me. I'm only doing landscape at present."

I followed him into a little studio he had fixed up for himself on the grounds. He turned his back to the window and began to work on one of his extraordinary out-of-door studies.

I could not get over my surprise at this method of doing

a landscape indoors, and when I mentioned the fact, Degas replied:

"Just an occasional glance out of the window is enough when I am travelling. I can get along very well without even going out of my own house. With a bowl of soup and three old brushes, you can make the finest landscape ever painted. Now take old Zakarian, for example. With a nut or two, a grape and a knife, he had material enough to work with for twenty years, just so long as he changed them around from time to time. There's Rouart, who painted a water-color on the edge of a cliff the other day! Painting is not a sport. . . ."

"As I was walking along Boulevard Clichy the other day," I said, "I saw a horse being hoisted into a studio."

"Degas picked up a little wooden horse from his work table, and examined it thoughtfully.

"When I come back from the races, I use these as models. I could not get along without them. You can't turn live horses around to get the proper effects of light."

"What would the Impressionists say to that, Monsieur Degas?"

Degas replied with a quick gesture:

"You know what I think of people who work out in the open. If I were the government I would have a special brigade of gendarmes to keep an eye on artists who paint landscapes from nature. Oh, I don't mean to kill anyone; just a little dose of bird-shot now and then as a warning."

"But Renoir paints out in the open air, doesn't he?" I queried.

"Renoir is a law unto himself. He can do anything he

likes. I have a Renoir in my studio in Paris I'll show you some time. Lord, what acid tones it has!" Degas was suddenly silent, then:

"Renoir and I do not see each other any more," he said.[1]

[1] Author's Note: Renoir and I were walking along the Grands Boulevards one day when the conversation turned to Degas. I had heard that Renoir did not like Degas' painting.

RENOIR: Degas liked to mystify people. I have seen him amuse himself like a schoolboy by puffing up a great reputation for some artist or other whose fame, in the ordinary course of events, was certain to perish the following week.

He fooled me badly once. One day I was on the driver's box of an omnibus, and Degas, who was crossing the street, shouted to me through his hands: "Be sure to go and see Count Lepic's exhibition!"

I went. Very conscientiously I looked for something of interest. When I met Degas again, I said: "What about your Lepic exhibition?"

"It's fine, isn't it? A great deal of talent," Degas replied. "It's too bad he's such a light weight!"

VOLLARD: I've heard Lautrec compared with Degas . . .

RENOIR: Ridiculous! Lautrec did some very fine posters, but that's about all . . . Just compare their paintings of *cocottes* . . . why, they're worlds apart! Lautrec just painted a prostitute, while Degas painted all prostitutes rolled into one. Lautrec's prostitutes are vicious . . . Degas' never. Have you even seen *The Patronne's Birthday?* It's superb!

When others paint a bawdy house, the result is usually pornographic —always sad to the point of despair. Degas is the only painter who can combine a certain joyousness and the rhythm of an Egyptian bas-relief in a subject of that kind. That chaste, half-religious side, which makes his work so great, is at its best when he paints those poor girls.

VOLLARD: One day I saw a *Woman in a Tub* by Degas in a window on the Avenue de l'Opéra. There was a man in front of it, tracing an imaginary drawing in the air with his thumb. He must have been a

DEGAS

Just then Zoé came in to announce that there was a visitor outside. It proved to be a lady from Paris who thought she would have a better chance of cornering the painter, for as I paused I heard him say to himself: "A woman's torso like that is as important as the Sermon on the Mount."

RENOIR: He must have been a critic. A painter would never talk that way.

VOLLARD: Just then a carpenter came along. He also stopped in front of the nude and exclaimed: "My God! I wouldn't like to sleep with that wench!"

RENOIR: The carpenter was right. Art is no joking matter.

VOLLARD: Did you ever have a chance to watch Degas make his etchings?

RENOIR: I used to go to Cadard's, usually after dinner, and watch him pull his impressions—I don't dare say etchings—people laugh when you call them that. The specialists are always ready to tell you that they're full of tricks . . . that the man didn't know the first principles of *aqua-forte*. But they're beautiful, just the same.

VOLLARD: But I have always heard you say that an artist ought to know his craft from the ground up. . . .

RENOIR: Yes, but I don't mean that fly-speck technique they call modern engraving. Some of Rembrandt's finest etchings look as if they had been done with a stick of wood or the point of a nail. You can hardly say that Rembrandt didn't know his business! It was just because he knew it from start to finish that he was not obliged to use all those fancy tools which get between the artist's thought and his execution, and make a modern engraver's studio look like a dental parlour.

VOLLARD: What about Degas as a painter?

RENOIR: I recently saw a drawing by Degas in a dealer's window —a simple charcoal outline, in a gold frame which would have killed anything else. But it held its own superbly. I've never seen a finer drawing.

VOLLARD: Degas as a colorist, I mean.

RENOIR: Well, look at his pastels. Just to think that with a medium so very disagreeable to handle, he was able to obtain the freshness of a fresco! When he had that extraordinary exhibition of his in 1885 at

painter in the country than in town. She came with a card from Monsieur de V., an old friend of Degas, and her first word was:

"Master!"

Durand-Ruel's, I was right in the midst of my experiments with frescoes in oil. I was completely bowled over by that show.

VOLLARD: But what I'm trying to get at is what you think of Degas as a painter in oils . . .

RENOIR: (interrupting) Look, Vollard.

(We had arrived at the Place de l'Opéra. He pointed to Carpeaux's group of the *Dance*.)

Why, it's in perfect condition! Who was it told me that that group was falling to pieces? I really haven't anything against Carpeaux, but I like everything to be in its place. It's all right to carry on about that kind of sculpture, since everybody likes it; I don't see any harm in that, but if they would only take those drunken women away and put them somewhere else . . . Dancing as taught at the Opera is a tradition, it is something noble; it isn't the Can Can . . . To think that we're living in an age that has produced a sculptor to equal the ancients! But there's no danger of *his* ever getting commissions. . . .

VOLLARD: Rodin has just had an order for the *Thinker*. And then there's his *Victor Hugo* and his *Gates of Hell* . . .

RENOIR: (impatiently) Who said anything about Rodin? Why, Degas is the greatest living sculptor! You should have seen that bas-relief of his . . . he just let it crumble to pieces . . . It was beautiful as an antique. And that ballet dancer in wax! . . . the mouth . . . just a suggestion, but what drawing!

What's the name of that old fool . . . that friend of Degas' who does nudes that look as if they're moulded on a living model—probably are, too . . . I never can remember names! Well, never mind. He kept after Degas until he finished that mouth, and of course he spoiled it.

—*From "Renoir, an Intimate Record," by Ambroise Vollard, translated by Randolph T. Weaver and Harold L. Van Doren, New York, Alfred A. Knopf, 1925.*

"Why 'master'?" returned Degas, with the rudeness characteristic of timid people.

The lady was unruffled, and addressed the painter again as if she were announcing some remarkable news:

"My son paints," she said winningly, "and he is so sincere about working from nature."

"And how old is he, madame?"

"He will soon be fifteen——."

"So young and already sincere about working from nature? Well, madame, all I can say is that your son is lost!"

The lady departed quite overcome, as might well be imagined.

VOLLARD: But how is a painter to learn his métier, Monsieur Degas?

DEGAS: He should copy the masters and re-copy them, and after he has given every evidence of being a good copyist, he might then reasonably be allowed to do a radish, perhaps, from Nature. Why, Ingres——

V.: Did you know Ingres?

D.: I was at his house once. I had a letter of introduction to him. I can't tell you how excited I was at the prospect— To think of meeting the great Ingres! Just as I was leaving he was taken with a dizzy spell, and began to reel. Fortunately I was near enough to catch him before he fell.

V.: Ingres never worked out of doors; but I understand that Manet tried his hand at *plein air,* didn't he?

D. (irritated): Never say *plein air* to me again! (A pause.) Poor Manet! To think of his having painted the *Maximilian* and the *Christ with the Angels,* and all the

others he did up till eighteen seventy-five, and then giving up his magnificent "brown sauce" to turn out a thing like the *Linge!*

V.: I understand that Courbet could not stand even the *Christ with the Angels.*

D.: Well, for one thing, Courbet contended that, never having seen an angel, he could hardly know whether they had behinds or not; and, what was more, in view of their size, they could not possibly fly with the wings Manet had given them.[1] But all that talk makes me sick. There is certainly some fine drawing in the *Christ*. And what transparent impasto! What a painter!

[1] See "Renoir, an Intimate Record," p. 46, by Ambroise Vollard, translated by Harold L. Van Doren and Randolph T. Weaver. (Alfred A. Knopf, 1925.)

61

Degas never cared very much for money. One of his sayings was: "In my day no one ever really 'arrived.' " And a trace of regret that those days were gone would creep into his voice.

Degas attended an auction at which one of his pictures had fetched a sensational price. As he was leaving, someone said to him:

"Quite a change from the days when you sold a masterpiece for a hundred francs, Monsieur Degas."

"Why do you say masterpiece?" asked Degas sharply. "If you only knew how sorry I am those days are over. I may have been a good horse to bet on, but it is just as well I didn't know it. If my 'goods' have begun to fetch such prices now, there is no telling what Delacroix and Ingres sell for. I won't be able to buy them for myself any more . . . !"

"But," I ventured, "you could have all the money you want, Monsieur Degas, if you would only dig into your portfolios."

"You know how much I hate to sell my work. Besides, I always hope eventually to do better."

Because of the many tracings that Degas did of his drawings, the public accused him of repeating himself. But

his passion for perfection was responsible for his continual research. Tracing-paper proved to be one of the best means of "correcting" himself. He would usually make the correction by beginning the new figure outside of the original outlines, the drawing growing larger and larger until a nude no bigger than a hand became life-size—only to be abandoned in the end.

Degas is said to have remarked to Manet:

"I shall be a member of the Institute before you." And when Manet laughed, he added, "Yes, and my drawing will do the trick."

The brilliancy of his pastels has always been considered extraordinary. The painter B. said to me one day:

"You know Degas, don't you? Won't you ask him for me where he buys his pastels? My wife is sure there is a trick in the way he gets a tone which is mat and luminous at the same time."

The next time I went to see Degas he was working in pastel.

"What a devil of a job it is to bleach the color out of pastel crayons! I soak them over and over again, and even put them in the sun. . . ."

I glanced at a pastel on an easel near by.

"But how did you manage to get such vivid color in those dancers? They are as brilliant as flowers. . . ."

"That? With the "neutral tone,' *parbleu!* . . ."

* * * * *

Degas used to say to me from time to time:

"Vollard, you ought to marry. You do not realize how terrible it is to be alone as you grow old."

DEGAS

I was telling Degas one day about a birthday party which had been given in honor of one of my grandparents. It was nine o'clock before dinner was finally served. In the excitement grandfather had almost been forgotten, at least so far as his evening mush was concerned, and the result was that the old man had almost died of starvation when a large plate of lobster and *paté de foie gras* was set before him.

"After nine o'clock!" Degas exclaimed in horror. "I'll wager my last sou that they had flowers on the table too."

"Well, they got their idea for the table decoration from a fashionable dinner described by Paul Bourget, and had scattered carnations around on the table cloth. Then one of the little girls said:

"'Grandpa, I'm going to let you play with my two little puppies 'cause this is your birthday.'"

"Yes," declared Degas, "but I think one could put up with even dogs and flowers rather than to have to endure solitude. Nothing to think of but—death. . . ."

He paused, and I finally ventured to ask:

"But what about yourself, Monsieur Degas? Why haven't you ever married?"

"I, marry? Oh, I could never bring myself to do it. I would have been in mortal misery all my life for fear my wife might say, 'That's a pretty little thing,' after I had finished a picture."

Degas and His Frames

I have already mentioned Degas' reluctance to allow any of his work to go out of his studio because he aspired to do better. This was a great point of pride with him. Another was the frames on his pictures, which he never permitted anyone to change once he had selected them.

When he would finally decide to part with one of his "articles" as he called them, it left the studio already framed, or, in the rare cases where he intrusted his buyer with an unframed picture, he always cautioned him to go to Lézin (the only framer Degas had any confidence in), adding, "I will go over later and choose the frame myself."

He had a special fondness for framing his drawings in *passe-partout* made of a blue paper used for wrapping sugar-cakes. He allowed for a half-inch of space between the edging and the picture. He always said, "None of those bevel-edged mats for me. They detract from the subject too much."

One of his favorite models of frame was "the coxcomb," which had a serrated edge, as the name indicates. He also reserved the right to select the color of his frames, being partial to the bright shades used for painting garden furniture. Whistler called them "Degas' garden frames."

It is easy to imagine Degas' irritation if a collector, believing it would increase the value of the picture, sub-

stituted a gold frame for the original which had been selected with such loving care. There was a row inevitably; Degas would refund the money and take the picture back. This happened numerous times. On one occasion Degas had gone to dine with an old friend of his, and as he entered the house, he discovered one of his pictures hanging in the hallway, brazenly decked out in a gold frame. He proceeded to take it down and, after removing it from the frame with the aid of a coin, returned home with it under his arm. His hosts waited for him to appear, and finally the lady of the house demanded: "Where is Degas? I thought I heard him coming in a little while ago."

But they never saw him again.

"Never trust a friend," was all Degas had to say about the matter. But meanwhile his "friend" was puzzled over what had happened and eventually imagined that the painter had been displeased with the frame because it perhaps had not seemed elegant enough.

"A frame that cost me five hundred francs!" he fumed. "What in Heaven's name does the man want?"

I remarked to Degas that he could feel sure that at least Monsieur Rouart would not change his frames.

"Oh, it's more than just the frame," replied Degas. "The fact is that I never feel really satisfied in letting any of my work go out of the studio. . . ."

But Rouart was not unaware of Degas' artistic conscience. He knew the artist's mania for adding final touches to his pictures, no matter how finished they were. And so to protect himself, he fastened the famous *Danseuses* to the wall with chains.

Degas would say to him: "Now that foot, Rouart, needs just one more little touch—"

But Rouart had no fear of losing his picture; he had confidence in the strength of the chains.

Degas had a horror of science. He was forever saying:

"Nobody will ever know the harm that chemistry has done to the art of painting. Look how the color has cracked in that canvas; what do you suppose they could have put into it?"

But in this particular case he had to admit that he was to blame for having worked over a white-lead priming that was too fresh.

He took great pains with the composition of the paper he used for pastel; however, by his very method of work (tracing after tracing) most of his pastels were of necessity done on tracing-paper. And then Lézin, the framer, would glue them onto bristol board.

Then there was the question of fixatifs. He would never use commercial fixatifs, for he found that they gave a shine to the surface, and also attacked the color. He used instead a fixatif specially prepared for him by Chialiva, an Italian painter of sheep, and it must be said that it is to him that posterity is indebted for having been an important aid in preserving Degas' work. Unfortunately, Chialiva died without revealing his secret. It was the more important for Degas to have a good fixatif, because of the manner in which he did his pastels; they were worked over and over again,

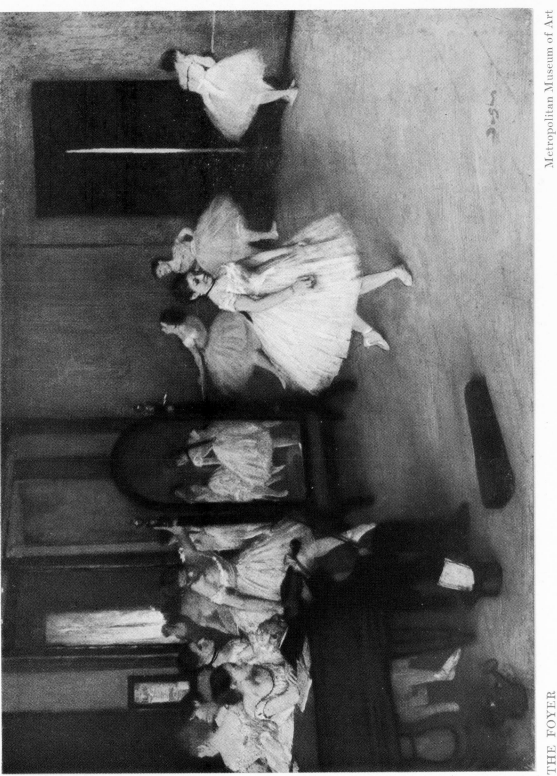

THE FOYER

and hence it was imperative to obtain perfect adherence between each successive layer of color.

* * * * *

We were discussing fresco. Degas said: "It has been the ambition of my life to paint on walls;—but you have got to remember that a house changes hands, and consequently one's work is apt to be destroyed."

But even if a collector had owned his own house, Degas would always have suspected that the minute he finished a fresco for him his patron would lose no time having it transferred to canvas and taken to a dealer.

"If I could only be certain that my work would not rise in value," he grumbled.

Degas used to say that if he had let himself follow his own taste in the matter, he would never have done anything but black and white.

"But what can you do," he would ask with a gesture of resignation, "when everybody is clamoring for color?" And it would almost seem as if he were right; he could do so much with just a bit of charcoal.

When Renoir came back from painting a portrait in Munich, I asked him what had struck him most in his patron's collection.

"There was a nude by Degas I shall never forget," he said. "It was the only thing you wanted to look at in the entire room. . . . It was like a frieze of the Parthenon."

* * * * *

One day I arrived at Degas' studio as he was getting a canvas ready. He was all at sixes and sevens.

"What a cursed medium oil is anyway! How is one to

know the best canvas to use—rough, medium or fine? And as for the preparation, is white lead better, or glue? Should there be one layer, two, or three?"

He was equally perplexed about the minium preparation the old masters used. He would struggle with canvas for a while and then go back to pastel.

"I will never touch a brush again," he would declare. Then, as if irresistibly lured by its very difficulties, he would return to oil once more.

I told him about the painter Y., who had come to me in great excitement, exclaiming: "Well, I've found my true style at last!"

Said Degas, "Well, I'm glad I haven't found my style yet. I'd be bored to death. . . ."

* * * * *

As a rule Degas had as great an aversion for the man who restored canvases as he had for the paint dealer. However there was one restorer named Chapuis, in whom he had confidence.

Degas was entirely opposed to the "ironing" process, which was supposed to "bind" canvas and painted surface together. The only method of remounting he approved of was *à l'italienne,* in which the iron was not used.

I used to meet Degas at Chapuis' shop with his latest Ingres or Delacroix, and he would watch uneasily while the picture-doctor examined the canvas. Finally he would begin peremptorily, "I want it re-mounted by the Italian method, you understand." Sometimes Chapuis would acquiesce, but other times he would reply:

70

"It is impossible to use the Italian method for this canvas, Monsieur Degas."

"Why?" Degas would demand, feigning anger.

"Because the canvas is too fine."

"Come, come," Degas would say, trying to appear domineering.

But Chapuis would shake his head and explain:

"The canvas is much too fine, and if I don't give it an ironing, it will wrinkle, and there will be blisters."

I recounted to Degas how a picture restorer whom I had known before Chapuis had treated a canvas. It was a fine-toothed linen which had wrinkled badly, and the man punctured the blisters which appeared, with a razor. Degas began to show signs of actual suffering at my story, and bade me stop.

"Well, Monsieur Chapuis, if you have to—" he said mournfully, but he immediately began to make further precautionary suggestions:

"Haven't you any confidence in me, Monsieur Degas?"

Degas had to admit that he had, but still it was hard for him to agree to that ironing. . . .

"Chapuis does pretty fine work," Degas confessed to me afterwards, "but he ought to have a gendarme about the place. That ass Henri H. was there the other day with a picture of a bust of a nude woman, and he said, 'A good many society ladies come to my house, and I thought the lower part of the torso was not quite proper, so I cut it off.' Did you ever hear anything so disgusting? To think that an imbecile like that hasn't been caught and locked up yet!"

71

"Was it a good picture?" I asked.

"No. It was by that Italian painter—you know—B.[1] But just the same, nobody has any right to tamper with another man's work."

And Degas practised what he preached. Monsieur B., a sculptor friend of his, made him a present of a life-size female nude in plaster. Degas lost no time in providing it with a glass case to protect it, and what is more, exhibited it for the admiration of connoisseurs. He happened to show it to F., who did not take kindly to it.

"No, Degas," he objected, "not that; I do not like serious pornography!" Whereupon Degas turned in appeal to Mlle. C.; but she was on the side of the enemy, for she said slyly:

"B. would never forgive you if he thought you didn't like his work, Degas."

"But," replied Degas ingenuously, "I've never told him one way or the other."

With such strict respect for the work of others, it is easy to imagine how Degas felt when anyone took the slightest liberty with his own. One day I noticed a damaged canvas of his on the wall, representing a man on a sofa and beside him a woman who had been cut in two, vertically.

VOLLARD: Who was responsible for cutting that picture?

DEGAS: It seems incredible, but Manet did it. He thought that the figure of Madame Manet detracted from the general effect. But I don't, and I'm going to try to paint her in again. I had a fearful shock when I saw it like that at

[1] Author's Note: Not Boldoni.

72

his house. I picked it up and walked off without even saying good-bye. When I reached home I took down the little still-life he had given me, and sent it back to him with a note saying: "Sir, I am sending back your *Plums.*"

V.: But you made up with Manet afterwards, didn't you?

D.: Oh, no one can remain at outs long with Manet. But the trouble is that he soon sold the *Plums*. It was a beautiful little canvas . . . (He paused.) Well, as I was saying, I wanted to restore Madame Manet to life and give the portrait back to him, but I have kept putting it off, and that is why you see it the way it is. I don't suppose I ever will get around to it now.

V.: Do you think that Manet would have been equally capable of cutting up a Delacroix or an Ingres?

D.: A Delacroix or an Ingres?—oh, yes, I believe so, the b——! But if I had, I think I would have finished with him for good and all.

Some time later I happened to meet Degas accompanied by a porter wheeling one of Manet's pictures on a cart. It was one of the figures from the subject picture entitled, *The Execution of Maximilian,* and showed a sergeant loading his gun for the *coup de grace.*

D. (pointing to the canvas): It's an outrage! Think of anyone's daring to cut up a picture like that. Some member of Manet's family did it. All I can say is, never marry, Vollard . . . I found this fragment, but the rest of it was gone. Lord knows where the other pieces are.

Degas was able eventually to find a few of the pieces in question, and he proceeded to glue them onto a canvas pre-

pared for the purpose, leaving necessary space for the missing parts in case they should ever be recovered.[1]

Besides being a great painter, Degas had a flair for collecting. He was dining one evening with Monsieur Alexis Rouart, who happened to mention, among other things, some Ingres drawings which he had just bought from Père Noisy, the cleverest "picture ferret" in all Paris. Degas was so impatient to see them that Rouart had to get up from the table and fetch the portfolio at once. Degas became so excited that nothing would do but that they must both leave dinner and rush to Rue Lafayette, where Noisy kept his shop open evenings to accommodate his old clients. The shutters were already lowered, but they went around to the court in the rear and were admitted.

[1] Author's Note: At the sale of Degas' estate, *The Execution of Maximilian* was acquired by the National Gallery in London, and the pieces, which the painter had assembled with such care, were again separated.

Père Noisy and His Shop

There was a little of everything in Père Noisy's port-folios, from Delacroix to Rops. And there were good bar-gains too. Noisy would say "my amateurs" as a father would "my children." And it was understood that his clients should always prove themselves worthy and deserv-ing of his interest in them. The worst ingratitude in Père Noisy's eyes was for anyone to try to bargain with him. He considered it a grave breach of confidence.

He was also known to be very accommodating. It is told how a painter once gave Père Noisy a batch of drawings on consignment, on condition that Noisy would clean up his studio before leaving. You can picture Père Noisy with a broom and duster— But that is another story.

As I was passing Père Noisy's shop one day, I caught sight of Degas inside, and entering, found him looking over some Daumiers. Next to him was an amateur looking through a folio of water-colors by Eugène Lami. The man held one up and said:

"They are like butterfly wings, aren't they, Monsieur Degas? Like a Renoir, as you said the other day. . . ."

"But Renoir lays his butterflies on lightly," replied Degas. "Lami nails them on."

Père Noisy always had one ear cocked to catch every-

thing that went on around him but he pretended to be very busy, and kept up a running-fire of conversation for the benefit of everybody. All at once he interrupted himself to reprove his wife for having made too cheap a sale.

"She did exactly the same thing the other day with that Rops drawing—you know the one, Monsieur Vollard, *Satan ensemençant le monde.* It was the only proof ever pulled, and such a price! . . ."

Just then I glanced out of the door and saw a woman in black with a little basket walking slowly back and forth on the sidewalk in front of the shop. Finally she seemed to make up her mind, and came in. Degas nudged his neighbor, and said:

"Look! Isn't she Forain's *Widow of the Artist* come to life?"

The woman made her way towards Noisy, who eyed her with disapproval, and demanded brusquely:

"What is it! What do you want?"

Madame Noisy, taking pity on the poor woman, came to the rescue.

"Don't you recognize Madame M.?" she said placatingly.

"Yes, yes," replied Noisy.

The woman murmured "Happy Birthday" to Père Noisy and timidly held out her basket. "Just some fruit from my garden," she said, almost in an undertone, and then without waiting turned and hurried out.

"There!" declared Madame Noisy. "You see, there are a few appreciative people still left in the world." And then by way of explanation, she said to the assembled clients,

"Monsieur Noisy just can't bear to be reminded of it when he has been kind to anyone."

"Tell us what happened, Père Noisy," someone in the group demanded.

Père Noisy gave a hasty glance at his wife as if to reproach her for her indiscretion, and then began:

"One day, when I was walking along the quais, I saw in front of me an old woman carrying a portfolio. I recognized it, by its color and shape, as one of those made by Latouche, a color-dealer who in the old days used to sell Corot and Rousseau—in fact, all the School of 1830. I said to myself, 'There may be a lot of good things in that portfolio.' Quickening my pace, I touched her on the shoulder.

" 'Madame, have you anything there you would like to sell, by chance?'

" 'Why yes,' she replied. 'I have some prints my husband left me. I did not quite know what to do with them, and I did not dare go into any of the big shops. . . .'

"I reassured her, and asked her to come to the house. We went into the store-room and examined the contents of the folio, and there, gentlemen, was one of the finest little collections of engravings I have ever seen. She asked only three hundred francs for the lot, and, from the expression on her face, it was plain that she would have come down by half. I paid her cash down on the spot. Then she told me she had some other things at home, and would be only too glad if she could sell them at once, for her furniture was

about to be seized by the bailiff. There were some family heirlooms, she said. I offered to look at them that very day.

" 'But it is in the suburbs. You will have to take the train.'

" 'Very well,' I replied. 'I will take the train.'

" 'You are very kind,' she said.

"I can hardly believe it yet, when I think of the things I found at that woman's house! Each item had the price her husband had originally paid for it, written on the back. I did not try to bargain with her——"

Here Madame Noisy interrupted with great dignity. "He hasn't told half," she stated. "He gave more than the woman asked."

Père Noisy was visibly embarrassed, and he mumbled:

"It came to four thousand nine hundred and fifty-five francs. I gave her a flat five thousand. The old woman burst into tears, took hold of my hands, and said:

" 'No father could be kinder to me than you have been!'

"You see, she did not lose sight of the fact that if it had not been for me, everything she owned would have been sold. Who knows what would have become of all those beautiful things? Probably someone would have got them who knew nothing of their real value. It nearly kills me every time I think of it.

"I give you my word," concluded Père Noisy, "I could have retired for life after that deal, if I had wanted to. But I have always loved art too much to do that."

Meanwhile Madame Noisy had looked into the little basket. Over the fruit was spread a paper doily with a lace border representing billing doves, and in the center was

written in blue ink, in a careful, round hand, "For my dear benefactor."

* * * * *

Degas and I left together.

"Did you watch the scene Noisy made with his wife as you came in?" he said. "He pretended to be upset because she hadn't asked enough for a print. All that is arranged between them beforehand. I recall one day he scolded his wife because she had let me have some Delacroix lithographs too cheaply. That annoyed me, so the next time I brought them back. Just as I entered the shop, what should I hear but Madame Noisy in the rear brow-beating her husband because he had made a bad bargain. I understood their little game then. Père Noisy is really a timid man beneath his gruff exterior; by raging and roaring at his wife, he makes the client feel sorry for her, and puts him in a state of mind where he dare not offer a lower price than the dealer has asked. I decided to keep my lithographs after all, and ever since then I've dealt only with Père Noisy."

Delacroix and Corot

In the old days before the doctor insisted on his taking regular walks for exercise, Degas would leave his studio when his afternoon's work was over, and, strolling down Rue Laffitte, would begin his tour at Durand-Ruel's; from there he would go to Bernheim-Jeune's and usually end up at my shop.

I can see him now standing in front of the display in Bernheim's window. On one side were Corot's *The Cathedral of Chartres* and *Houses at Ville de Volterre,* and on the other was a *Christ in the Tomb* by Delacroix.

"What do you suppose they would ask for those pictures, Vollard?" he demanded as I came up.

I confessed I had no idea. "Weren't you in at Bernheim's a while ago?" I asked.

"I did drop in a minute with the intention of sounding them out; but when it came right down to it, I didn't have the courage to ask the price. You know such Corots and Delacroix as those aren't to be had for a mere song. I thought of making a proposition to exchange them for some of mine, but the old Indian Prince [1] would never have considered it for a minute."

"How do you know he wouldn't?" I countered.

[1] Degas' nickname for Monsieur Josse Bernheim.

This seemed to hearten Degas and bring him to a definite decision, for he said after a pause: "I believe I'll try it. I'll go in and see what luck I have."

He came out almost immediately after, exclaiming:

"Would you believe it, those two Corots were sold this morning for almost nothing! Moreau-Nélaton took them. Well, I'm going to have the Delacroix anyway. I left a deposit on it to make sure."

I was taking lunch with Degas on the day the picture was delivered. Zoé hurried into the dining-room all out of breath.

"Monsieur, the Delacroix is coming up!" she cried.

Degas rushed out without even taking time to remove the napkin from his collar.

But once he had carefully examined his new acquisition from every angle, Degas stacked it with the others, face to the wall. He would never share with anyone the special pleasure he got from "discovering" his treasures all over again. He would wait till he was alone, and then return to look them over one by one. I can see him now, hunched over a half-open folio, as if to hide its contents from any profane eye.

One day a Monsieur D. came to see him.

"He knows a good thing when he sees it," Degas confided to me as the visitor was being ushered in. "I am going to bowl over with one of these lithographs by Delacroix." It so happened that Monsieur D. had come for the purpose of asking Degas' permission to have a photograph made of the very lithograph in question.

"What for?" demanded Degas suspiciously.

"For reproduction," answered the vistor, and thinking he "had" Degas, he pursued, "There are only two known proofs of this picture, and the other one cannot be found."

"Indeed!" retorted Degas. "The other one cannot be found, eh? Well, I can tell you, sir, that I put in a good twenty years hunting for this Delacroix. . . . And you can do the same."

Monsieur D. made a last attempt.

"But the public has a right to art as well as you, Monsieur Degas," he protested.

"I don't give a damn about the public! That Delacroix is not coming out of its portfolio."

Monsieur D. was obliged to depart without even having caught so much as a glimpse of the lithograph. After he had gone, Degas remarked to me:

"Upon my word, Vollard, the day will come when they'll be trotting Raphael and Rembrandt about on the boulevards, just because the public is supposed to have a right to beauty." [1]

[1] Author's Note: It was just about this time that a law had been proposed to establish "travelling museums" which would draw on regular museums for their material.

On Decorations

One day I ran into Degas just as he was alighting from a tramway.

"It's the same old story every time I get into one of those things," he announced impatiently. "It was just my luck to get caught between two great hulking girls who were not only carrying huge bunches of flowers, but wore regular swords for hatpins. And you should have heard the impudence of one of them, after she had almost put my eye out!"

"If you had worn the Legion of Honor, Monsieur Degas," I said, "they would surely have been more polite."

Degas looked at me in absolute amazement.

"Look," I went on, indicating a man who was urinating against the fountain in Place Pigalle. "Do you think that fellow would dare do such a thing with a gendarme standing right beside him, if he didn't have a red ribbon in his buttonhole?"

Degas shook his head.

"Roujon sent Mallarmé to me once to ask if I would accept the Legion of Honor. If it hadn't been for the table between us, I don't think I should have let him get out of the house alive. . . ."

"But," I replied, "I shouldn't be surprised if after you

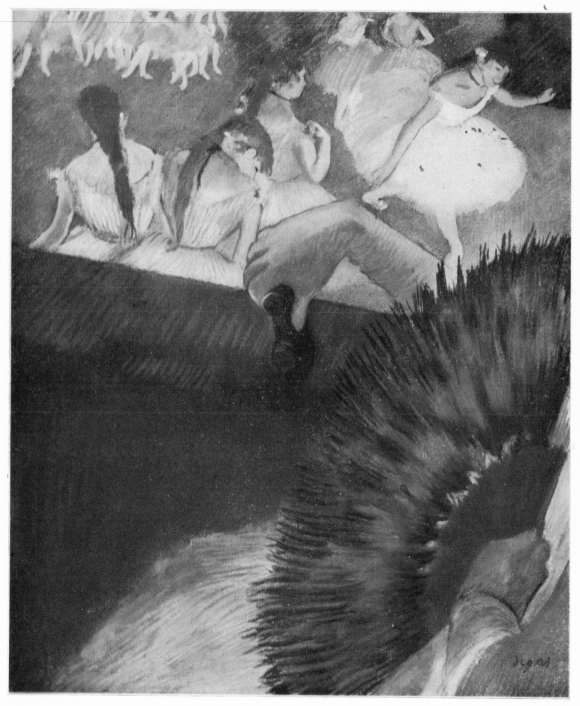

BALLET FROM THE LOGE

are gone people said that your greatest sorrow in life was that you never received the Legion of Honor."

Degas laughed aloud at the idea. Nevertheless, at the exhibition of his pictures held shortly after his death, I heard someone remark:

"Poor Degas! Tirard [1] says that his greatest regret was that he was never given the Legion of Honor."

[1] Tirard was at one time President of the Council of Ministers.

Degas had an ardent distaste for any kind of posing in public, and it was a warm reception Monsieur Sacha Guitry received when he came around one day to take a moving-picture of the painter.

Monsieur Guitry could not understand why Degas would refuse so peremptorily what Renoir had granted without the slightest hesitation. He did not know that Renoir was rarely able to say "no" to anyone.

However, the author of *l'Illusioniste* had more than one trick in his bag. He had arrived at Degas' house just as the painter was preparing to go out. Guitry withdrew to the sidewalk and waited. A few minutes later a crowd gathered, and there was much commotion; Guitry was "shooting" Degas.

* * * * *

Degas gave up his omnibus rides towards the end of his life. He took long walks instead, which never seemed to tire him. But his strength was deceptive, and proved eventually to be a sign of a serious bladder trouble, which worried him a great deal.

It so occupied his mind that one day when the model came to work for him, he forgot the traditional "Get undressed." He was walking about with a bowl of cherry-

bark tea in his hand and suddenly he looked up absently and said:

"Do you have trouble urinating? I do, and so does my friend Z."

I met Degas one evening on the Boulevard des Italiens, and, on learning that he was on his way home, offered to accompany him. He lived then near Place Clichy. Owing to his affliction, which made him want to walk eternally, he took me a roundabout way by the Bastille. As we went along, Degas would stop in front of shop-windows, look at the displays and the advertisements pasted on the plate glass, and then stare at me questioningly. I would then proceed to read them to him: *Chaussures de Limoges; Ribby habille mieux; Poule aux gibier.*

He stopped in at a café located in the building where he lived, and while he sipped a cup of hot milk, he would watch the billiard players in the back of the room. This was a regular habit with him, and when he would drop in and not find them there, he would go up to the cash girl and inquire where they were.

One day I went to the café with him, and we found the billiard players on duty. As he studied them he turned to me and said:

"People call me the painter of dancing girls. It has never occurred to them that my chief interest in dancers lies in rendering movement and painting pretty clothes."

It was quite another story when it came to movement or gestures that were of no use to him artistically. One time he was taking tea at Madame F.'s house. A lady sitting opposite him kept swinging her foot interminably, and De-

gas soon began to fidget. Suddenly he leaped forward with the agility of a much younger man, and threw himself at the feet of the lady. She smiled at him at first, but immediately jumped up with a shriek: her "adorer" had caught hold of the offending foot, and cried:

"Sit still! Sit still, or you will drive me crazy!"

Another time, when dining with a friend, his host reached forward to ring the table bell. Degas seized his arm.

"What are you going to do?" he said.

"Ring for the maid."

"Why do you ring?"

His friend looked at him in consternation, while Degas continued:

"Isn't she coming?"

"She is waiting for me to ring."

"But," declared Degas, "I don't have to ring for Zoé."

Degas the Sculptor

When Degas' eyesight became so poor that he could see only with great difficulty, he gave up painting for sculpture. He is quoted as having said: "I must learn a blind man's trade now." But this cry of self-pity was somewhat exaggerated, for he had always had a great interest in modelling, and had, in fact, exhibited his famous piece, *La danseuse à la robe de tulle,* at the World's Fair of 1878.

But none of his sculpture ever got beyond the wax or clay stage. He always said that he could not take the responsibility of leaving anything behind him in bronze; that metal, he felt, was for eternity.

Degas made a great number of statuettes, but hardly more than one or two were cast during his life-time, and those in plaster only. One day he showed me a little dancer that he had done over for the twentieth time.

"I believe I've got it at last," he announced. "One or two days more work and it will be ready for the caster."

The next day, however, all that remained of the little dancing girl was the original lump of wax from which she had sprung. Seeing my disappointment, Degas said:

"All you think of, Vollard, is what it was worth. But I wouldn't take a bucket of gold for the pleasure I had in destroying it and beginning over again."

89

DEGAS

If he was hard on his sculpture, he was no less destructive with his painting if the mood so happened to strike him. I remember in particular a *Milliner's Workshop* which Mlle. Cassatt once spoke to me about.

"If you should ever happen to find that picture," she told me, "I know an American who will pay any price for it."

Oddly enough, I eventually ran across the picture at Degas' studio one day. I repeated to him what Mlle. Cassatt had said.

"It is a great temptation," he answered, thoughtfully. "I could buy myself a Delacroix that I've had my eye on for some time. But there's always been something about that canvas that I don't like."

And with that he took up his brush and painted out one of the figures.

THE LAST YEARS

Towards the end of his life, Degas was forced to leave his house in Rue Victor-Massé, which he had lived in for more than twenty-five years. It formed a part of a block of houses which was condemned to be torn down, and to depart from it was a terrible blow to him. He searched a long time before he could find a new place to suit him, and he finally took an uncomfortable little apartment on the Boulevard Clichy. He would not hear of going into a house which had any sort of central heating; just the very mention of *confort moderne* put him into a rage.

"Imagine having rooms all equally hot!" he exclaimed indignantly. "If I want to be warm all I have to do is stand near the fire-place, and when I feel warm enough, I move away."

This conversation had taken place in his "winter dining-room," a small room with a low ceiling right next to the kitchen. It had a fire-place in it which had never been known to draw.

Ellen André,[1] the actress, was present that day. Degas was such an admirer of her talent that he even went to the Boulevard theatres to see her play. Degas' favorite theatre,

[1] Author's Note: Ellen André had at one time posed for Degas.

91

in fact, was the Montmartre, to which he often went with Renoir and Zandomeneghi.

But, to return to the incident, Degas was enjoying the company, and was not in the least aware that the fire-place was smoking badly. He stretched himself comfortably, and said:

"This is a delightful room, isn't it, Ellen?"

* * * * *

Degas gave up working entirely soon after he had moved in 1912. His hearing became worse and he was now almost totally blind. I can see him yet being led across the street by a gendarme.

It was strange, but there were a few things he could see, or perhaps feel visibly, as it were. If anyone was dining with him and happened to help himself to a dish on the table, Degas would say:

"Be careful not to make a spot on the cloth."

Gradually he was sunk into a dream, and would inquire, "Well, how is the war going," in the same tone that he would ask Zoé, "Where is my tea?"

His indifference to everything increased, and finally included even himself. One day he entered a tobacco shop dressed in a shiny cape and old felt hat, a pitiful old man with an untidy beard. The clerk leaned over the counter and handed him a little package of *Caporals*.

"Here, old fellow, is something for you," she said kindly.

But in spite of his forlorn appearance, there was always a certain distinction about him to the end. He had the air of having stepped out of a portrait, say, of the Italian

school. Degas had, in fact, Italian ancestors, and as he grew older he came to look more and more like a Neapolitan.

He spent his last days wandering aimlessly about Paris; but usually his ramblings ended up at his former home, now rapidly disappearing under the hands of the wreckers. The last load of plaster and rubbish was carted away, there was a plank fence along the sidewalk, and all that was left was a solitary old man standing for long hours peering pathetically through the cracks at what he could not see: the drear and barren ground.

THE END

PLATES

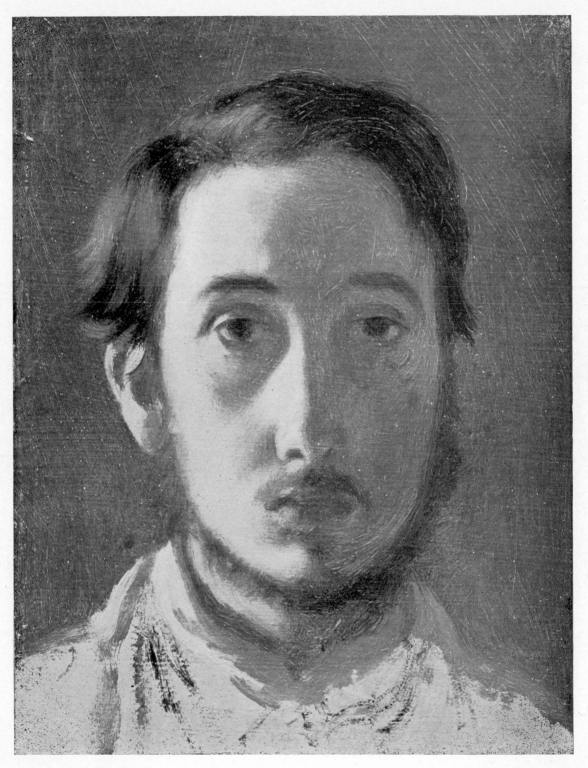

1. SELF-PORTRAIT Paul Rosenberg, Paris

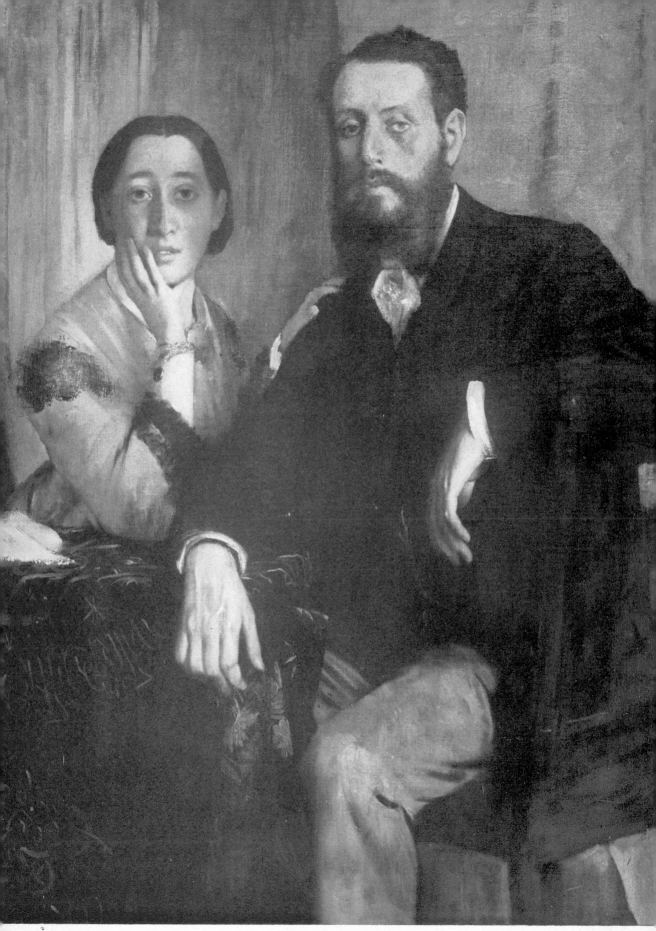

2. PORTRAIT OF DUKE AND DUCHESS OF MORBILLI

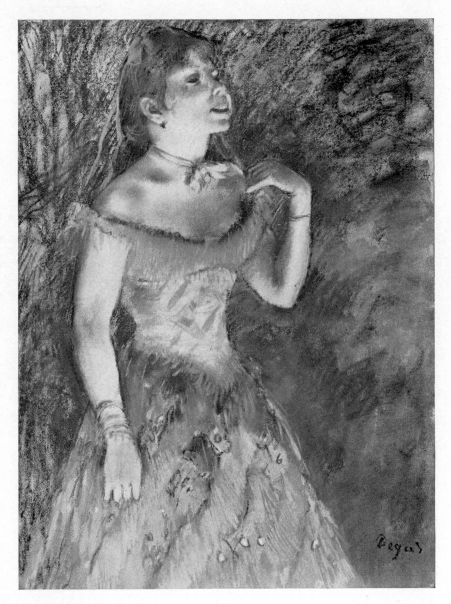

3. THE CAFE SINGER

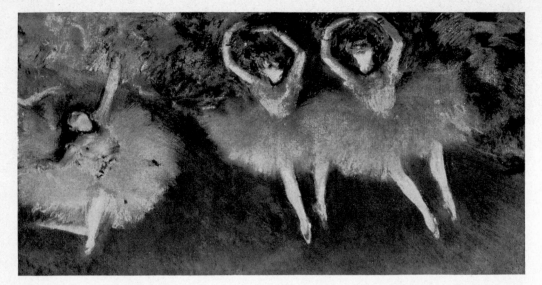

4. BALLET DANCERS Mrs. Edgar Scott, Philadelphia

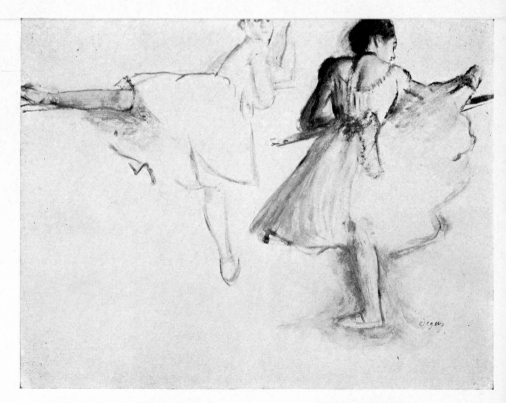

5. DANCERS AT THE BAR César M. de Hauke, New York

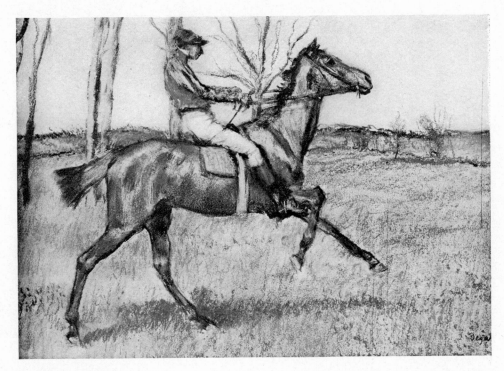

6. THE JOCKEY The Pennsylvania Museum of Art

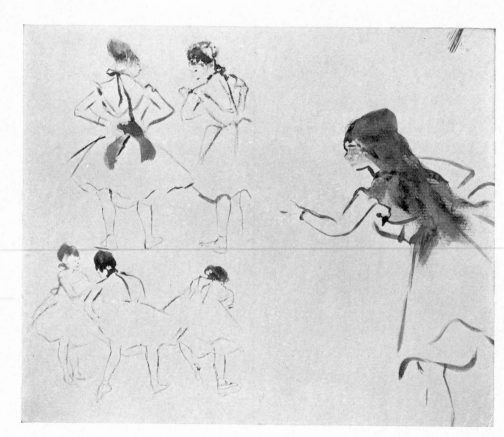

7. BALLET DANCERS Paul J. Sachs, Cambridge

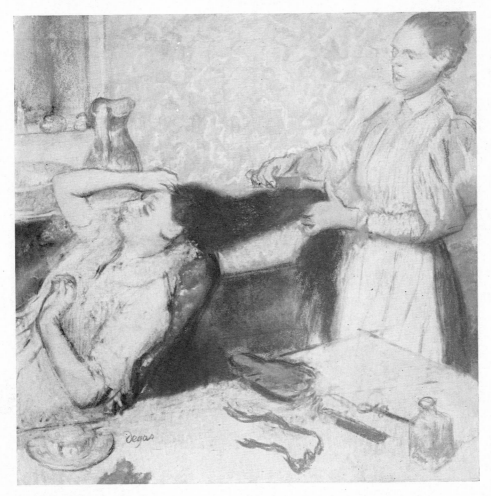

8. COMBING THE HAIR Pierre Matisse, New York

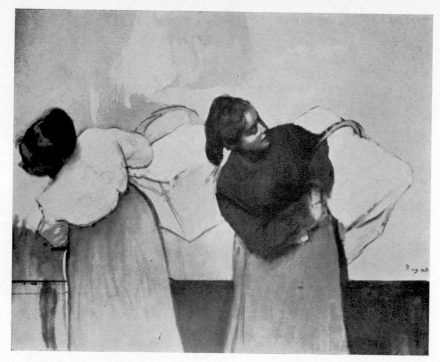

9. THE LAUNDRESSES Mr. and Mrs. Howard J. Sachs, New York

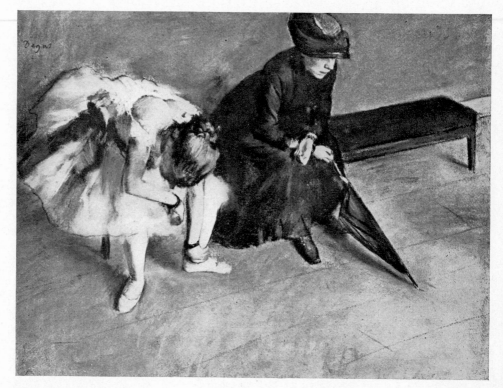

10. WAITING Horace Havemeyer, New York

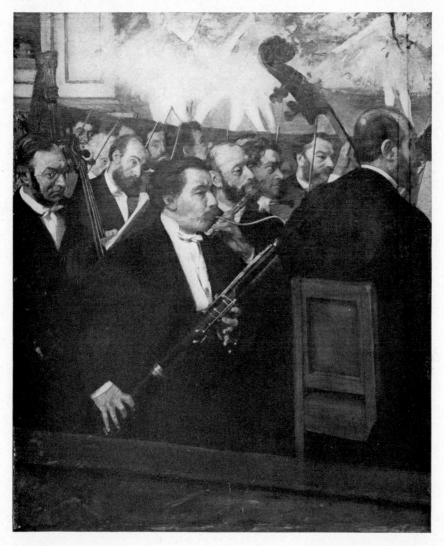

11. THE ORCHESTRA Musée du Louvre, Paris

12. HEAD OF A YOUNG WOMAN Musée du Louvre, Paris

13. PORTRAIT OF MISS CASSATT (at the Louvre)
Henry P. McIlhenny, Philadelphia

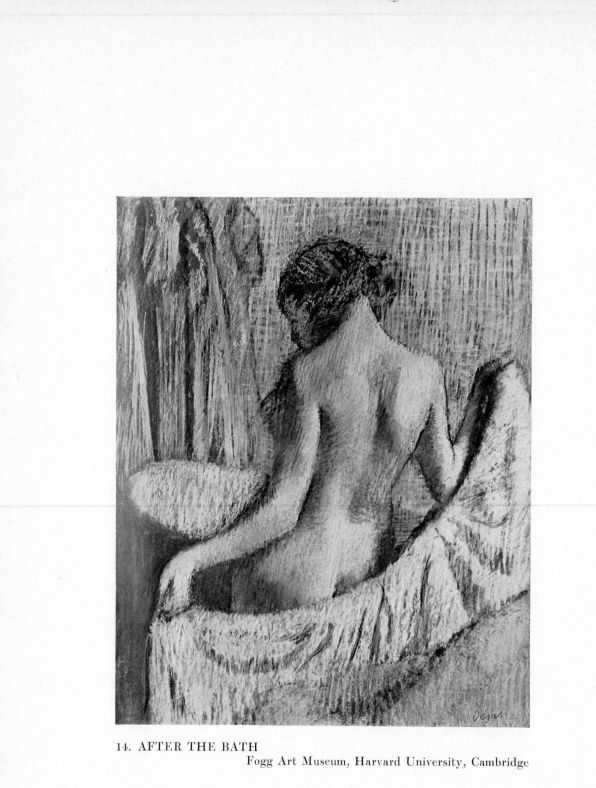

14. AFTER THE BATH

Fogg Art Museum, Harvard University, Cambridge

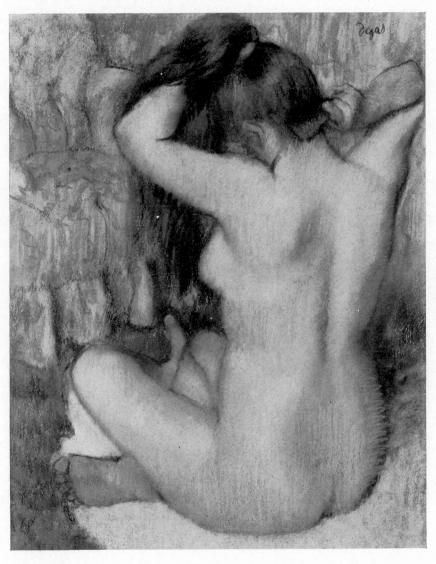

15. NUDE WOMAN ARRANGING HER HAIR

Durand-Ruel, Paris and New York

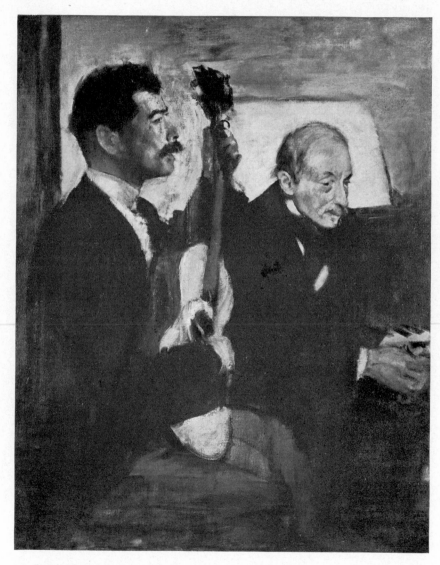

16. DEGAS' FATHER LISTENING TO PAGANS

John T. Spaulding, Boston

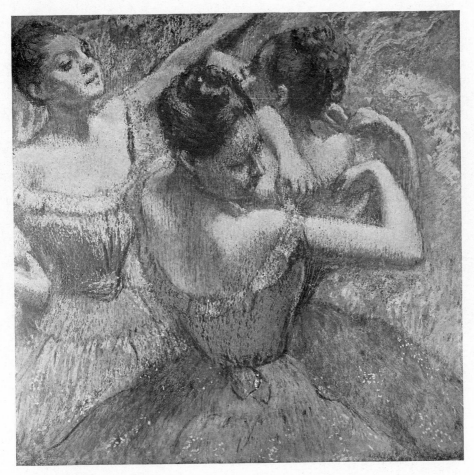

17. THE DANCERS Toledo Museum of Art, Toledo

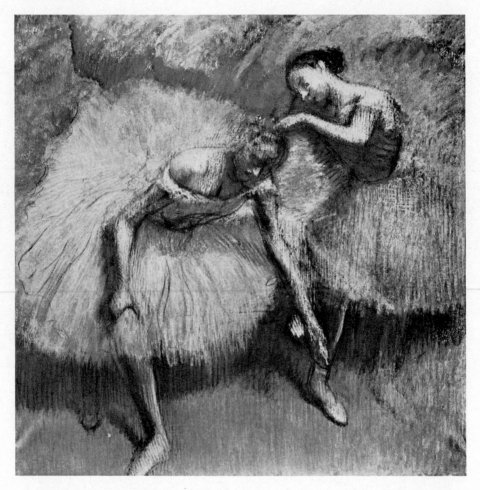

18. BALLET DANCERS Paul Rosenberg, Paris

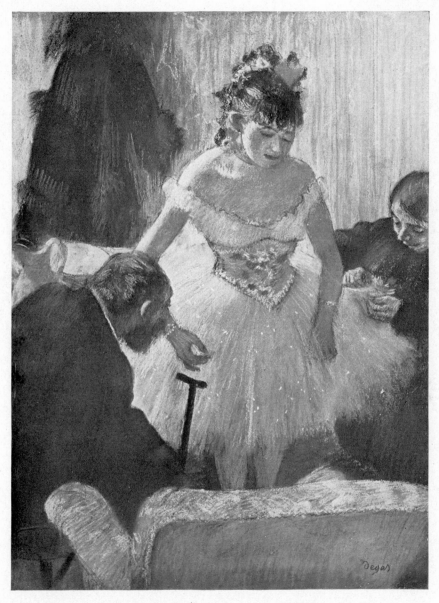

19. BALLET DANCER IN HER DRESSING ROOM
 Mr. and Mrs. Peter B. Frelinghuysen, New York

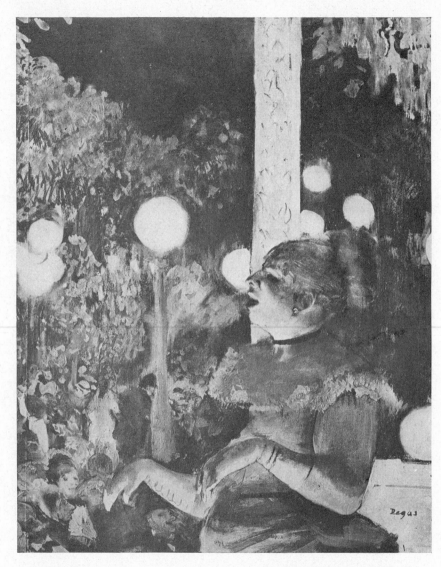

20. THE SONG Horace Havemeyer, New York

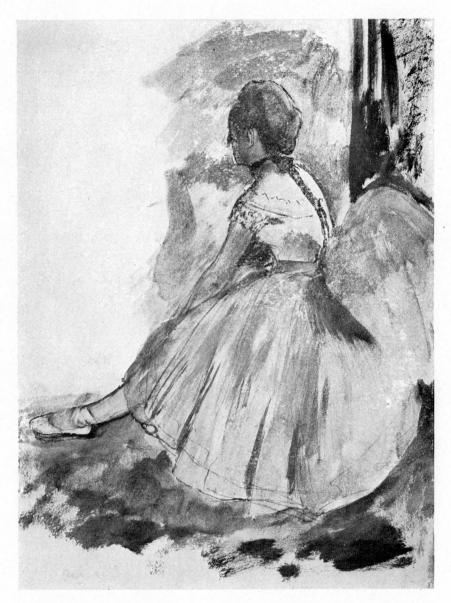

21. STUDY OF A DANCER John Nicholas Brown, Providence

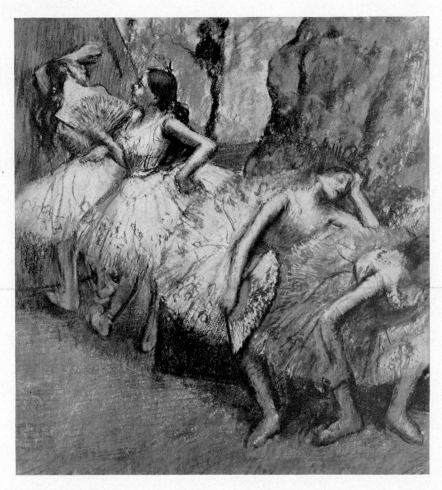

22. DANCERS IN THE WINGS City Art Museum of St. Louis

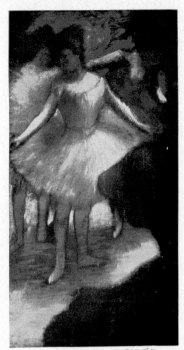

24. IN THE WINGS

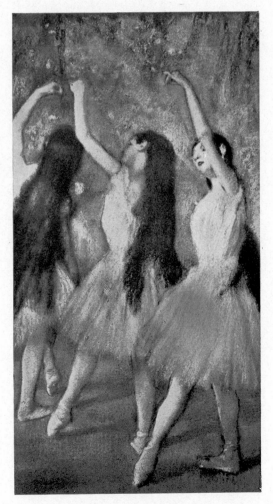

23. THREE DANCERS IN GREEN
Durand-Ruel, New York

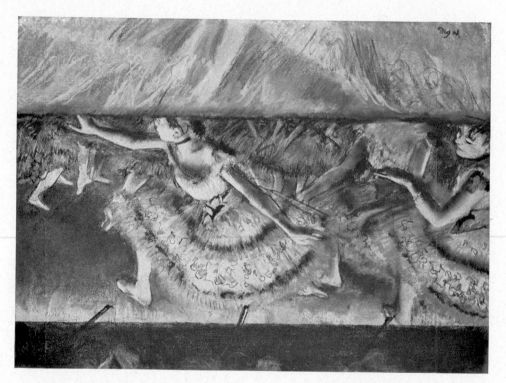

25. THE LOWERING OF THE CURTAIN Robert Treat Paine, 2nd, Boston

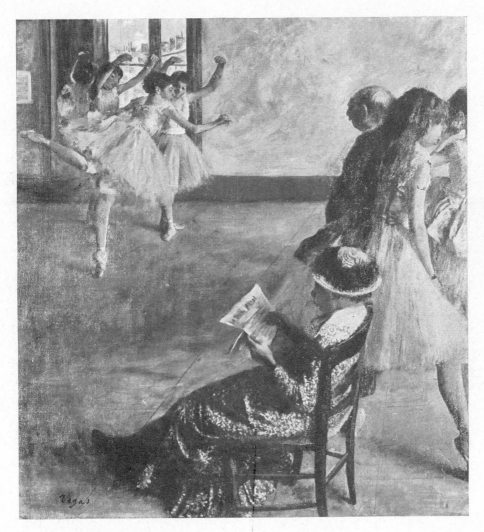

26. THE BALLET CLASS

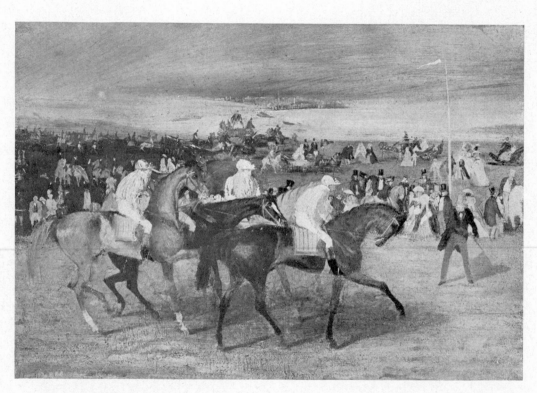

27. AT THE RACES: THE START Fogg Art Museum, Harvard University, Cambridge

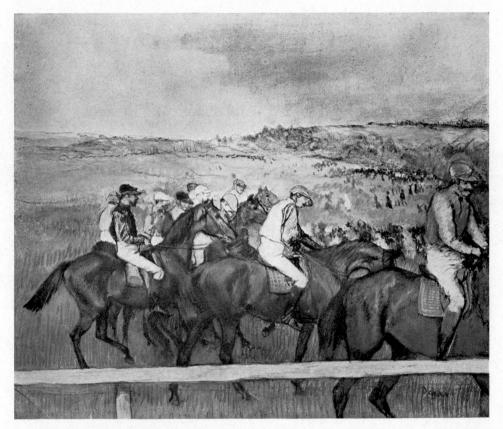

28. BEFORE THE RACE Mrs. Murray S. Danforth, Providence

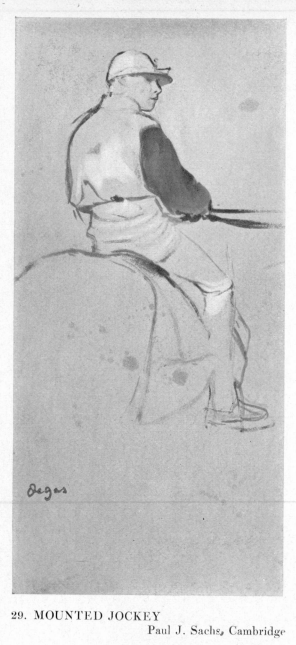

29. MOUNTED JOCKEY

Paul J. Sachs, Cambridge

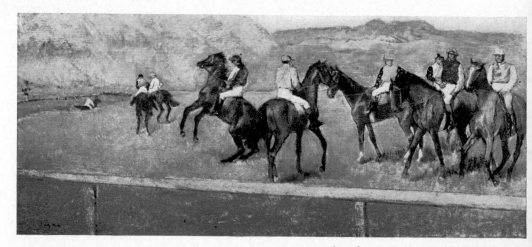

30. THE START OF A RACE Paul Rosenberg, Paris

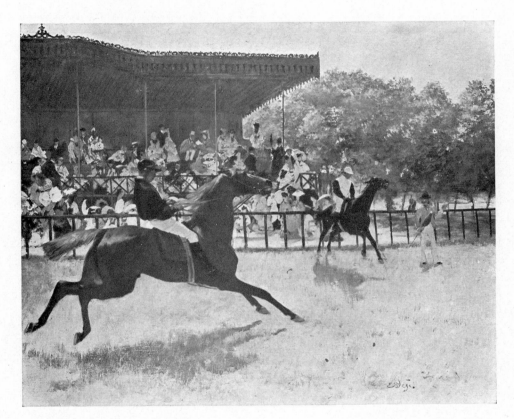

31. THE FALSE START John Hay Whitney, New York

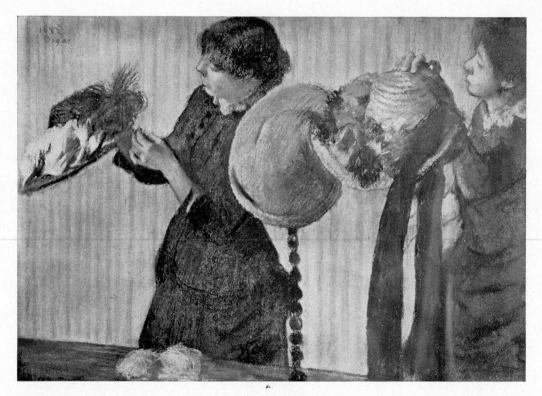

32. THE MILLINERY SHOP Mr. and Mrs. Peter H. B. Frelinghuysen, New York

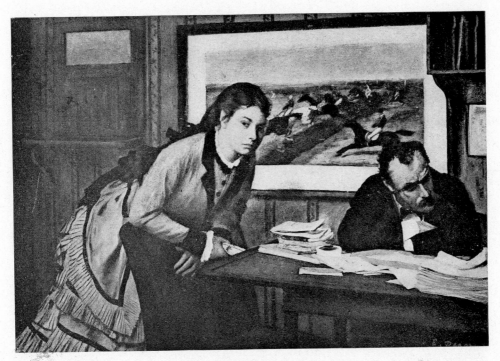

33. POUTING Metropolitan Museum of Art (H. O. Havemeyer Collection)

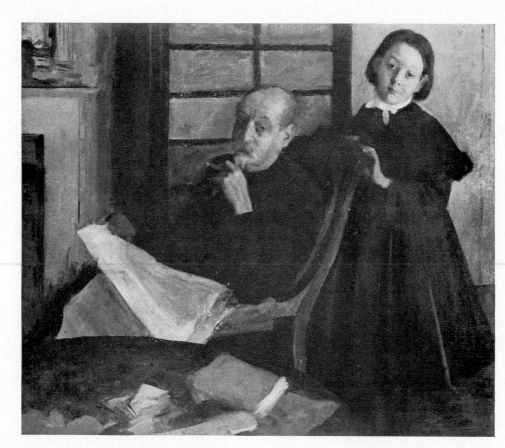

34. UNCLE AND NIECE

Art Institute, Chicago (Mr. and Mrs. L. L. Coburn Collection)

35. JEPHTHAH'S DAUGHTER Smith College Museum of Art, Northampton

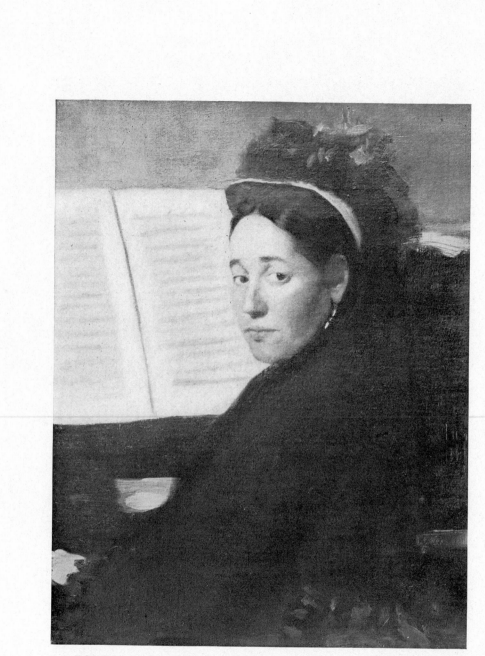

36. PORTRAIT OF MLLE. DIHAU The Louvre, Paris

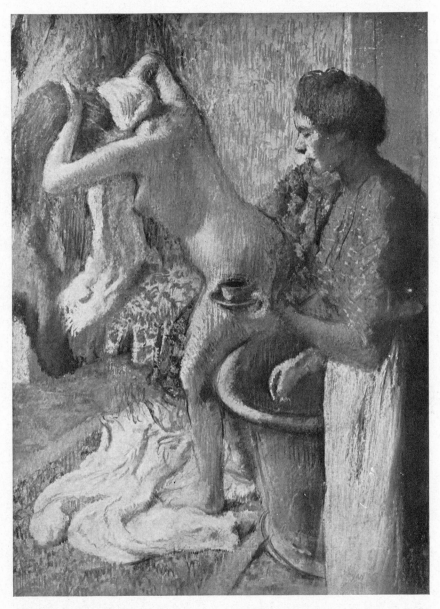

37. LA PETITE DEJEUNER Durand-Ruel, Paris and New York

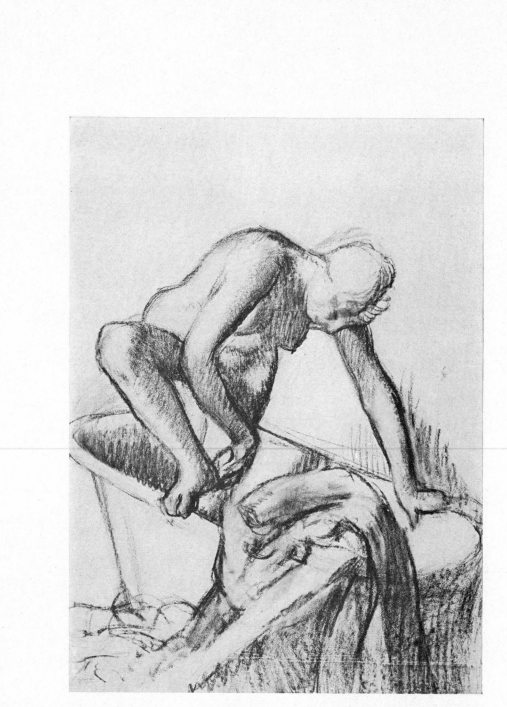

38. NUDE FIGURE BATHING Paul J. Sachs, Cambridge

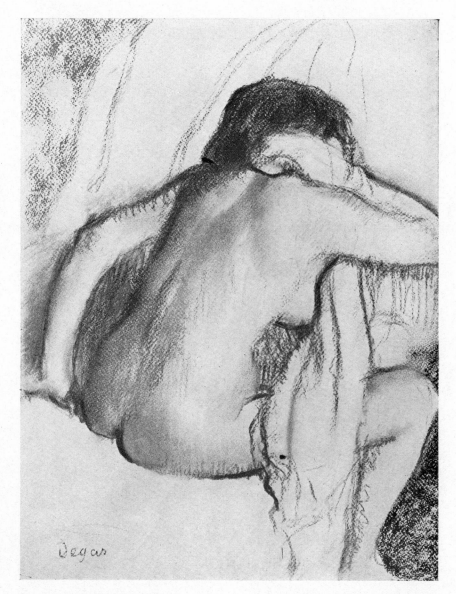

39. AFTER THE BATH Paul J. Sachs, Cambridge

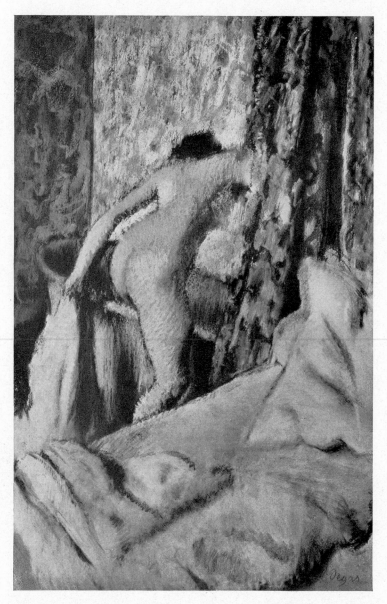

40. THE MORNING BATH
Art Institute, Chicago (Potter Palmer Collection)

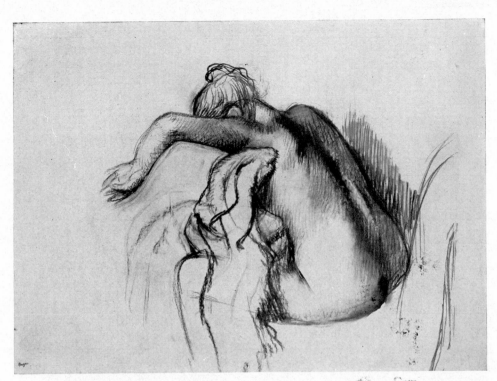

41. AFTER THE BATH Paul J. Sachs, Cambridge

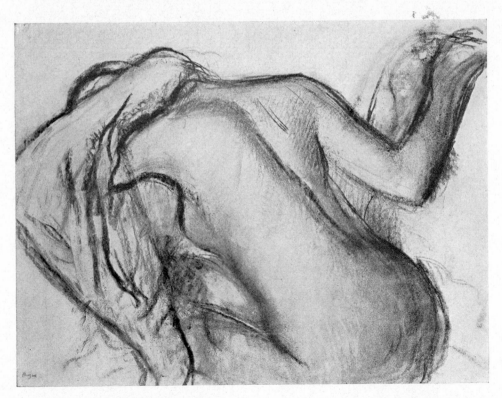

42. AFTER THE BATH Paul J. Sachs, Cambridge

43. PORTRAIT OF ACHILLE DE GAS

Chester Dale Collection, New York

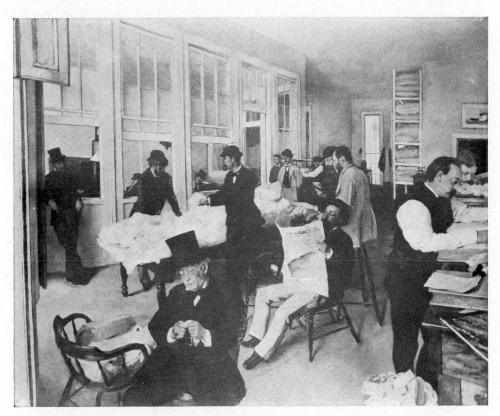

44. THE COTTON MARKET IN NEW ORLEANS Musée de Pau

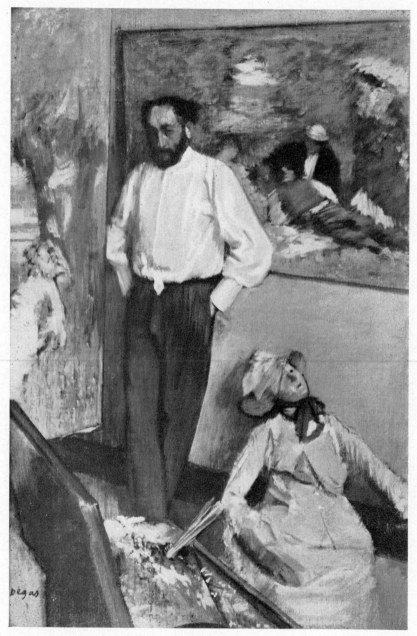

45. THE MAN AND THE PUPPET C. S. Gulbenkian, Paris

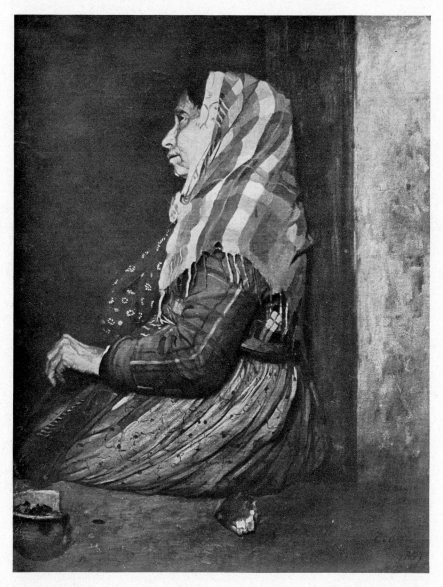

46. ROMAN BEGGAR WOMAN Mrs. Chester Beatty, London

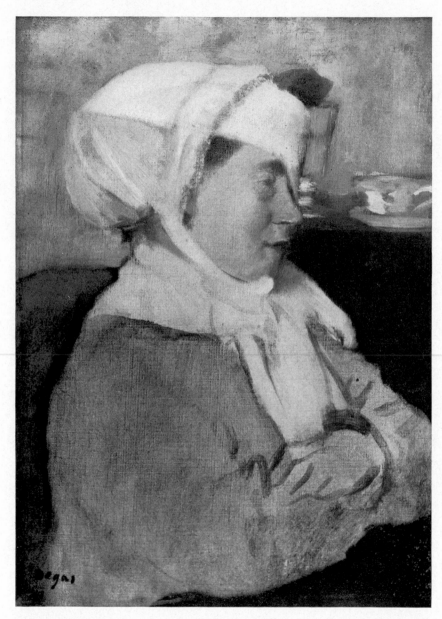

47. WOMAN WITH BANDAGED HEAD

Collection of Denys Cochin, Paris

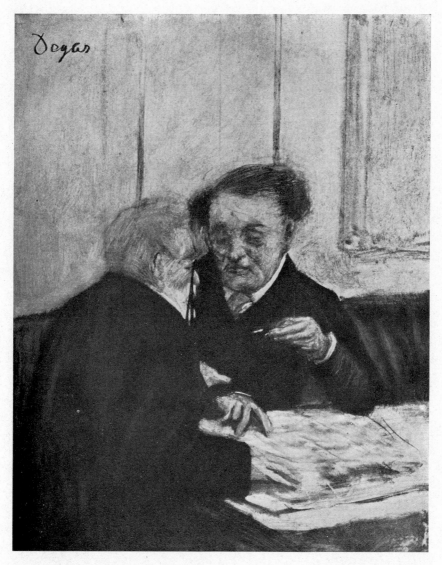

48. LE CAFÉ DE CHÂTEAUDUN
Mr. and Mrs. Robert Woods Bliss, Washington

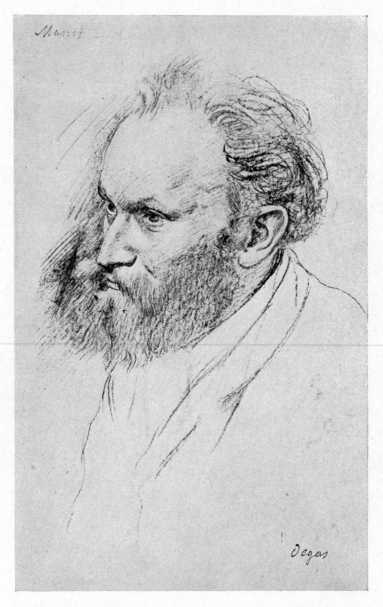

49. HEAD OF EDOUARD MANET Ernest Rouart, Paris

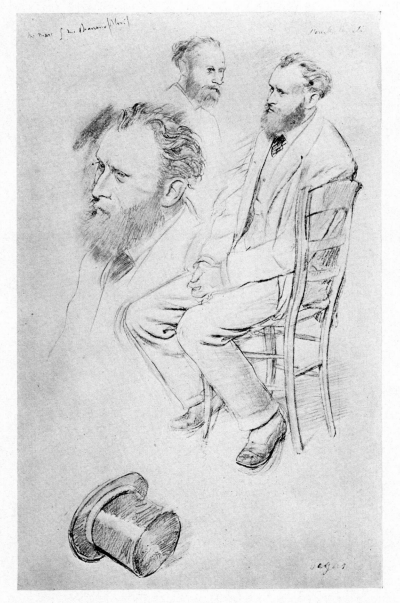

50. PORTRAIT OF EDOUARD MANET Ernest Rouart, Paris

51. PORTRAIT OF EDMOND MORBILLI

Museum of Fine Arts, Boston

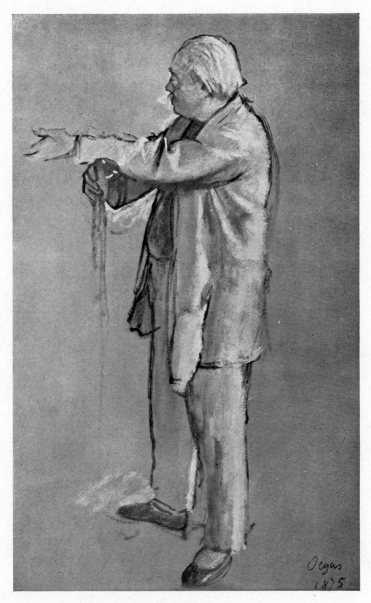

52. THE BALLET MASTER

Henry P. McIlhenny, Philadelphia

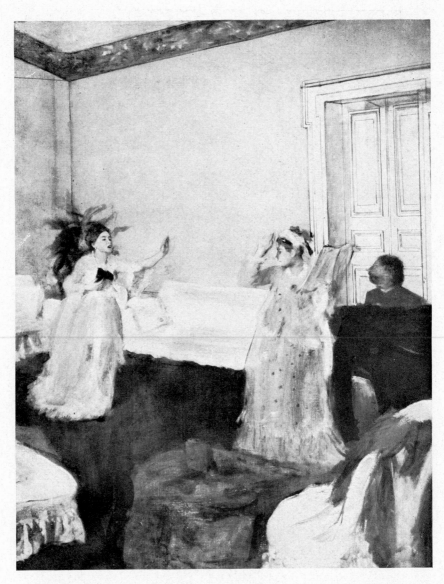

53. DOUBLE PORTRAIT Mr. and Mrs. Robert Woods Bliss, Washington

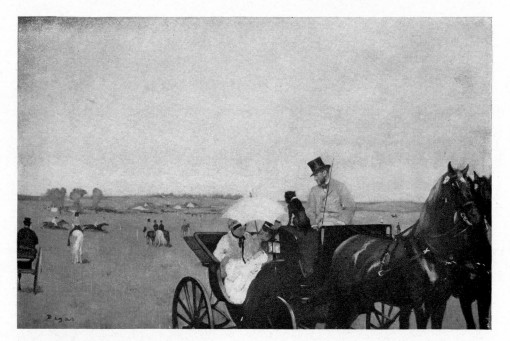

54. CARRIAGE AT THE RACES Museum of Fine Arts, Boston

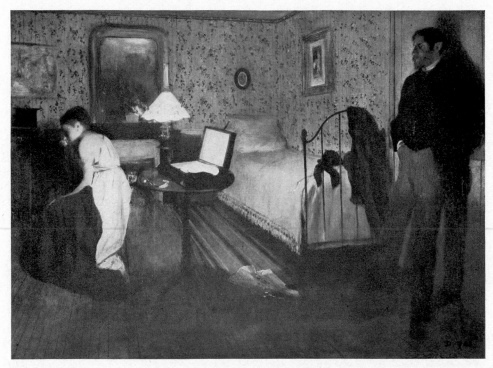

55. LE VIOL Harris Whittemore, Naugatuck

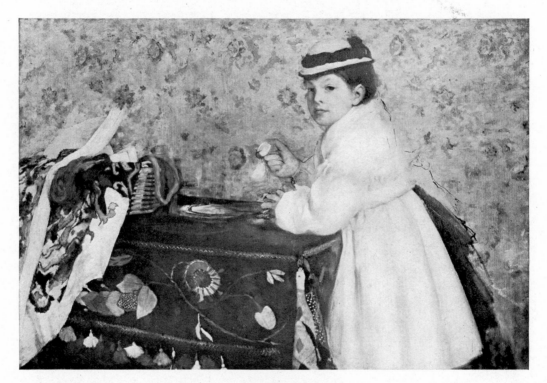

56. PORTRAIT OF MLLE. HORTENSE VALPINÇON

Wildenstein and Company, Paris and New York

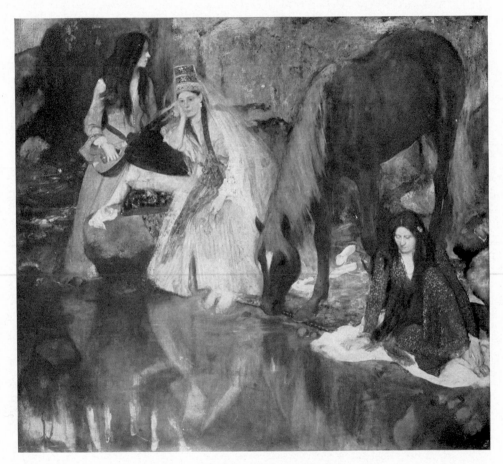

57. MLLE. FIOCRE IN THE BALLET "LA SOURCE"

The Brooklyn Museum, Brooklyn

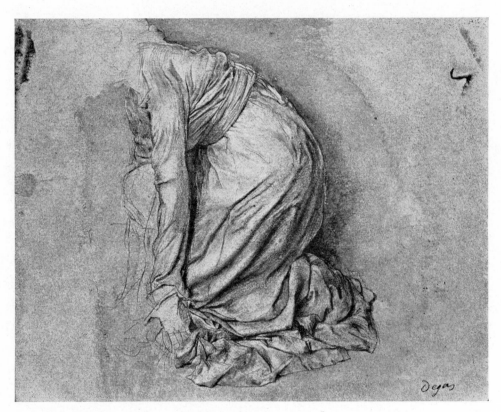

58. STUDY FOR "SÉMIRAMIS" The Louvre, Paris

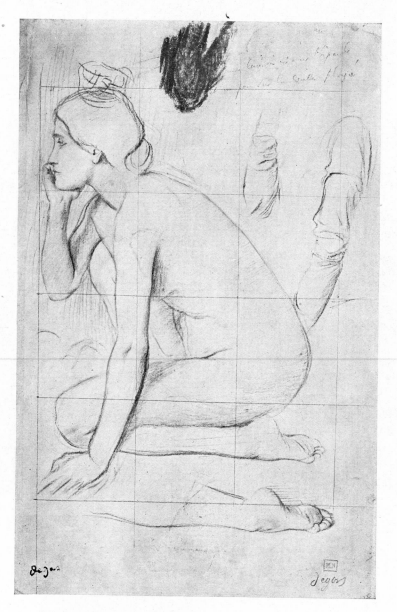

59. STUDY FOR "SÉMIRAMIS" The Louvre, Paris

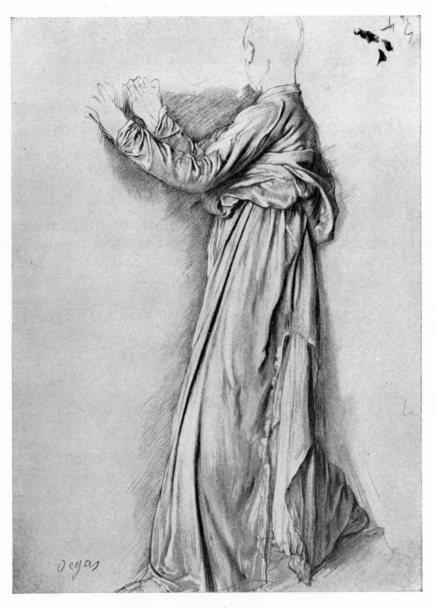

60. **STUDY OF DRAPERY FOR "SÉMIRAMIS"** The Louvre, Paris

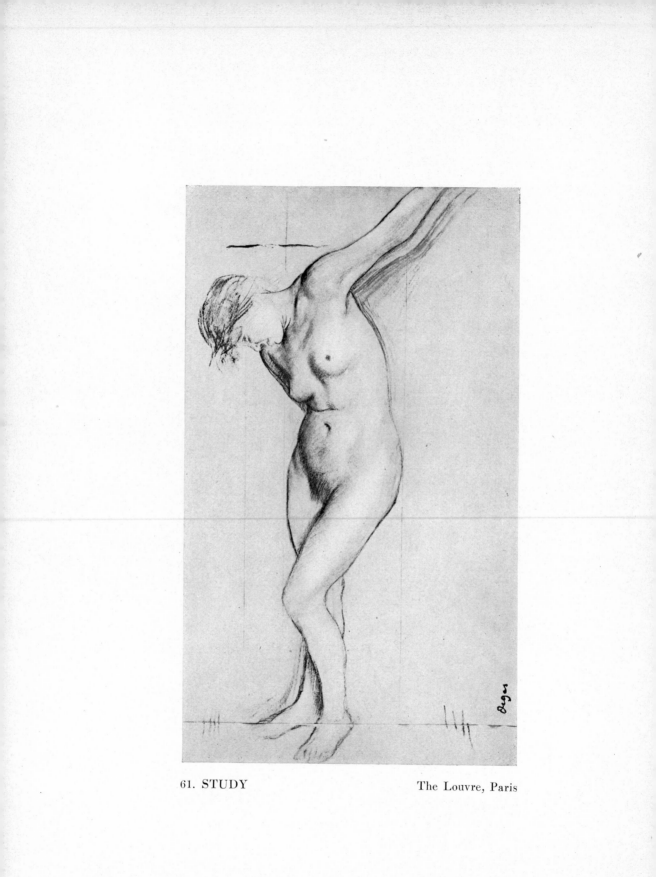

61. STUDY The Louvre, Paris

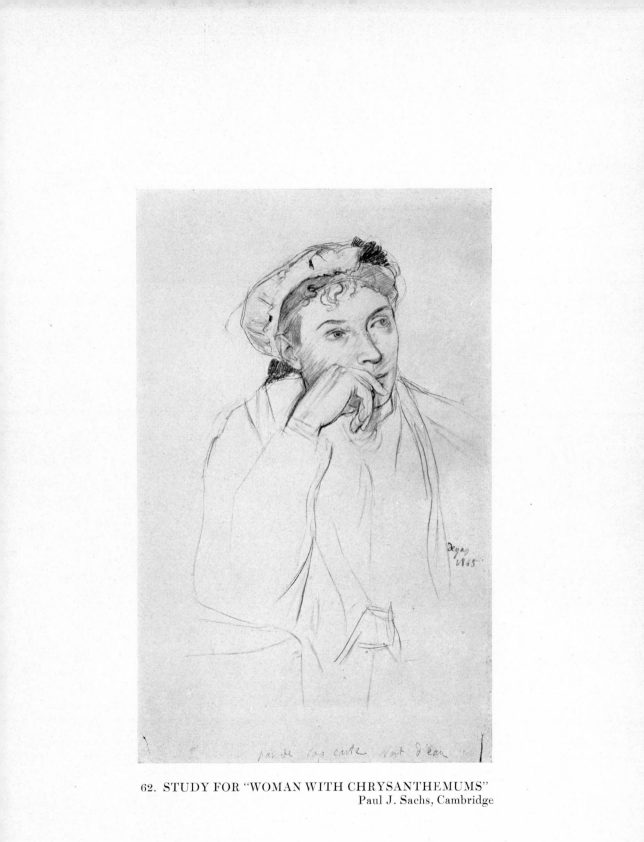

62. STUDY FOR "WOMAN WITH CHRYSANTHEMUMS"
Paul J. Sachs, Cambridge

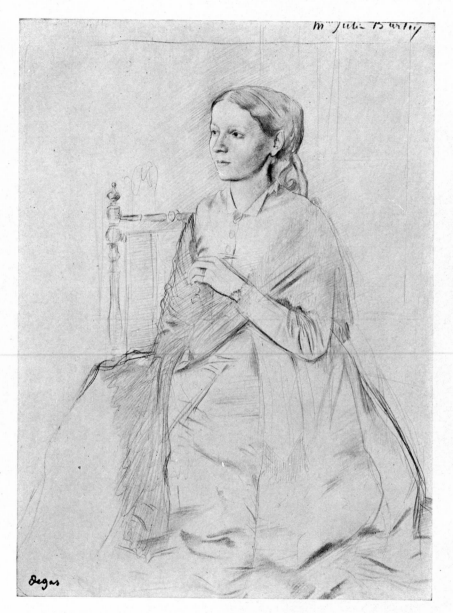

63. PORTRAIT OF MME. JULIE BURTIN

Paul J. Sachs, Cambridge

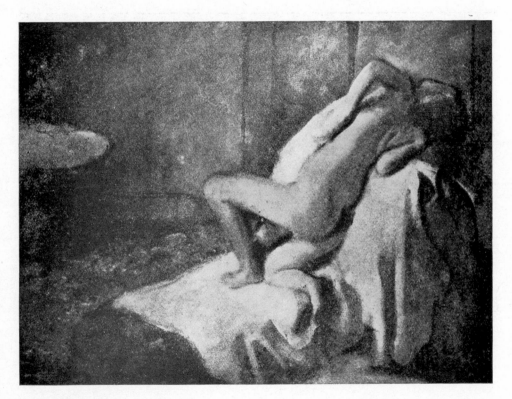

64. AFTER THE BATH Dr. Georges Viau, Paris

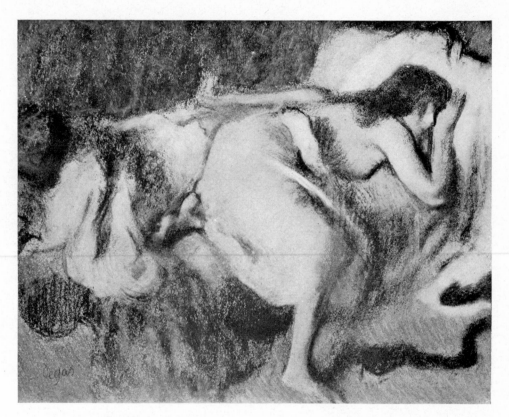

65. RECLINING GIRL Sam A. Lewisohn, New York

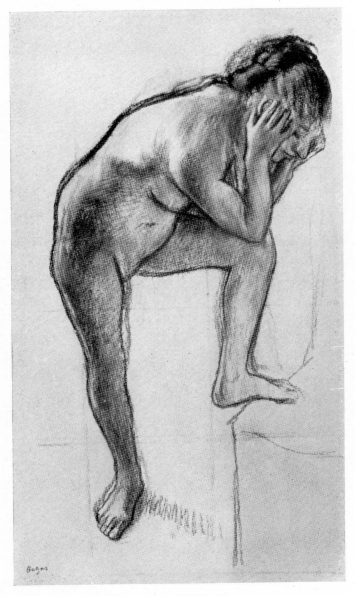

66. STUDY OF A NUDE WOMAN

Dr. Georges Viau, Paris

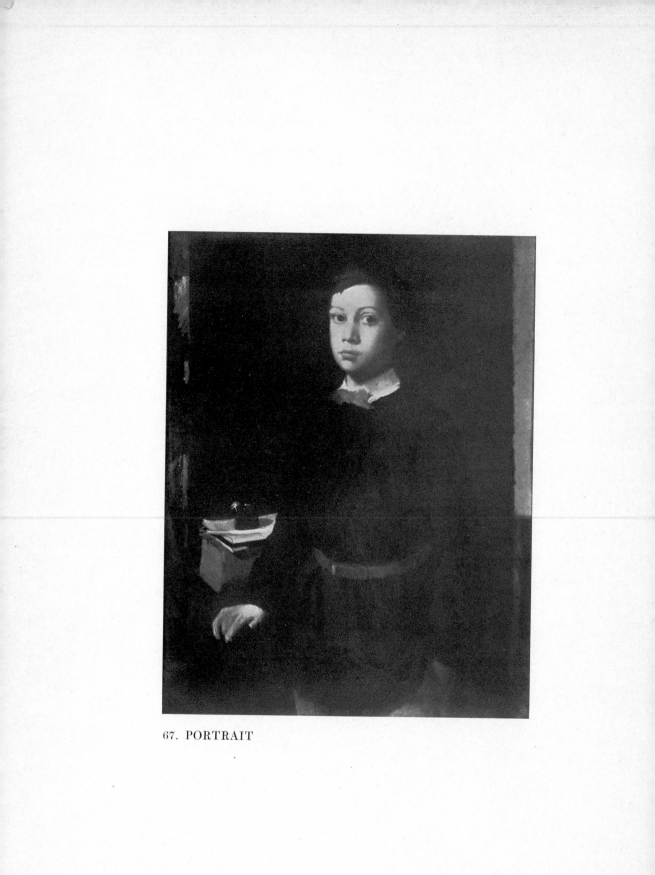

67. PORTRAIT

68. SELF-PORTRAIT John Nicholas Brown, Providence